IMAGES
of America

PATAPSCO VALLEY STATE PARK

Enjoy the park!
Ed Johnson

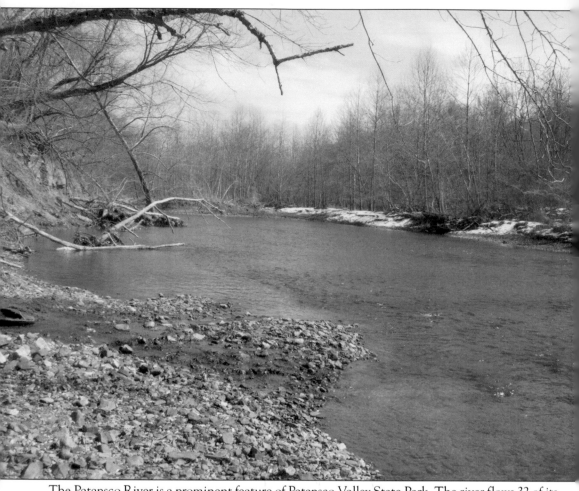

The Patapsco River is a prominent feature of Patapsco Valley State Park. The river flows 32 of its 39 miles through Maryland parkland. Beginning in Carroll County, it continues through Howard, Baltimore, and Anne Arundel Counties before ending up in the Chesapeake Bay. Historical events of the past along the river greatly affected the development of commerce, transportation, communication, and the Baltimore Harbor. This river has been, and continues to be, enjoyed by waders, swimmers, paddlers, fishers, hikers, and other visitors, as well as the abundant wildlife that live in this protected area. (Authors' collection.)

ON THE COVER: A family on a Sunday drive in the 1920s stops into the Patapsco Forest Reserve to enjoy a picnic lunch. Over the years, other visitors began to discover this hidden gem. Today, over a million guests a year visit Patapsco Valley State Park from all over the world to enjoy a day in nature. (Courtesy of DNR.)

IMAGES
of America

PATAPSCO VALLEY
STATE PARK

Betsy A. McMillion and
Edward F. Johnson

ARCADIA
PUBLISHING

Published by Arcadia Publishing
Charleston, South Carolina

Printed in the United States of America

Library of Congress Control Number: 2018961461

For all general information, please contact Arcadia Publishing:
Telephone 843-853-2070
Fax 843-853-0044
E-mail sales@arcadiapublishing.com
For customer service and orders:
Toll-Free 1-888-313-2665

Visit us on the Internet at www.arcadiapublishing.com

This book is dedicated to our loving spouses, Bill McMillion and Pat Johnson, because of their patience, never-ending support, and encouragement, which helped us make this book a reality, and to all who help make the park such a positive experience for the public.

CONTENTS

ACKNOWLEDGMENTS

Writing this book was a labor of love, to introduce park visitors to the wonders and rich history of the land that is now Patapsco Valley State Park (PVSP). All author proceeds from this book will be donated to the Friends of Patapsco Valley State Park to fund future preservation, educational, or recreational projects within the park. We spent over three years and hundreds of volunteer hours working closely with PVSP and Maryland Department of Natural Resources (DNR) staff. Our research incorporated information and photographs from various sources, including interpretive signs throughout the park, hundreds of articles and documents found in the park's visitor's center, local libraries, museums, local historical societies, DNR's website, Maryland Historical Trust documents, current and former park employees, and local citizens who generously shared their information with us. This book would not have been possible without the support and help of many people. We want to especially thank the following who worked so closely with us, and either shared several photos with us and/or helped us with history facts: Robert Bailey, historical planner with the Maryland Park Service; Lt. Gregory Bartles of the Maryland Conservation Agency Museum; and Lisa Wingate, historic preservation consultant at Preservation Consulting. We also want to thank renowned authors of local publications and books for information used in this book for sharing their photo collections: John McGrain, William Hollifield, Daniel Toomey, Henry Sharp, and Paul Travers. Lisa Vicari, Catonsville Room of the Baltimore County Public Library, helped us research and discover many great photos and information. Others who shared their advice, history expertise, and photos include Elkridge Heritage Society (especially Mary Bahr), Howard County Historical Society (especially Shawn Gladden), Ruth Sherwood, Joe Maloney, Ed Lilley, Lucy McKean, Russell Ridgely, and many others who are acknowledged under the photos they contributed. Special thanks to park staff for their assistance in gathering photos and information for the book, including Rob Dyke, Joe Vogelpohl, Dennis Cutcher, Alyssa Henn Myers, Jamie Petrucci, Andy Rinta, Jeff Mouton, Max Buffington, and the Friends of Patapsco Valley State Park (especially Eric Crawford).

INTRODUCTION

The area now known as Patapsco Valley State Park has evolved through many stages since the 1600s. It started as a prime hunting ground for the Susquehannock and Piscataway Indians. This fully forested river valley was teeming with game, fish, and shellfish. After the first Englishman explored the valley, tobacco plantations took hold, and the industrial revolution in Maryland soon followed with the first iron forges along the river. Trees were removed in favor of tobacco planting, and the iron forges demanded vast amounts of timber to turn into charcoal, thus greatly depleting the forested land. The nearby port of Elkridge Landing was busy with goods shipped to England during Colonial times, but silt washing downriver had a negative effect on the harbor.

The inventions of the steam locomotive, the Corliss steam engine, and the telegraph greatly enhanced the development of commerce, manufacturing, transportation, and communication as well as the Baltimore Harbor. Also, the construction of the Thomas Viaduct train bridge made a vital connection with Washington, DC, and was a critical site during the Civil War.

After President Jefferson's embargo on foreign goods went into effect, textile, grain, and paper mills, as well as mill towns, sprang up along the river. Dams were built at each mill site, as waterpower from the Patapsco River was the only power at hand. Goods from these mills were shipped all over the world until many of these early ventures were severely damaged or destroyed by a major flood in 1868.

The early 1900s saw the first 43 acres of land donated to the State of Maryland by a Catonsville landowner, and Patapsco soon became Maryland's first state park. This land initially became the Patapsco Forest Reserve, which was managed by the first state forester in Maryland. He opened the forest to the public, enabling people to encounter and enjoy recreation in the outdoors. The addition of the electric-generating Bloede Dam and Victor Bloede's Baltimore County Water and Electric Company provided needed electric power and clean drinking water to nearby communities. Additional parkland was purchased, and the park expanded. The Civilian Conservation Corps established Camp Tydings in the Avalon Area of the park in the early 1930s. The young corpsmen built shelters and picnic areas, enhanced roads, created trails, and planted trees, and made Patapsco into a functional park with amenities. It then became Patapsco State Park. At the onset of World War II, the camp was converted into the country's first conscientious objector's camp and continued the conservation work already begun.

During the 1940s and 1950s, the Avalon area of the park was one of the most frequently used parts of any park in Maryland. Its popularity grew.

Additional land was added to the park, opening up several new and unique areas along the Patapsco River. Floods in the 1930s and 1950s, however, continued to damage parkland and facilities, and it reached a critical level with severe devastation in the early 1970s when Tropical Storm Agnes destroyed much of the park. It took several years to clean up and rebuild, but the park rebounded to become a valuable part of the lives of so many park patrons of all ages who come to hike, picnic, camp, fish, ride horses, and engage in a variety of other nature-related outdoor

experiences. Park staff and volunteers provide a wide range of nature programs for youth and adults year-round, and each of the park's areas provides unique opportunities for the nearly one million visitors each year who come from all over Maryland, many other states, and numerous other countries.

Significant firsts occurring within the park from the colonial period to the present include those that were first in Maryland, first in America, and first in the world.

The ranger position, which originated for the purpose of protecting colonial lands and landowners, evolved into a rugged, mounted forest warden in the early 1900s, patrolling the forest reserve monitoring campers, campfires, and the forest resources. He protected people as well as the natural resources. Later, a car was provided that was equipped with modest firefighting equipment should the need arise. It was not until the 1970s that women joined the ranger group as well as the maintenance crew in the park. Around this time, a volunteer emergency rescue squad of park employees was formed and trained in the park. They were ready and equipped for rock-climbing accidents, lost visitors, and people who may have fallen through ice.

Chapter one focuses on the early history of the park, the early inhabitants, and the key people instrumental in the development and evolution of the park. Chapters two and three tell of the rich, extensive history of former mill towns throughout the Avalon and Orange Grove areas. Chapter four shows the effects of major storms and floods throughout the Patapsco Valley. Chapter five addresses the development and evolution of the Hilton, Daniels, Hollofield, Pickall, McKeldin, and other popular areas that extend along 32 miles of the Patapsco River. Chapter six covers the 21st-century park amenities, environmental concerns, and preservation efforts. Chapter seven describes some important firsts that occurred within park property.

One

EVOLUTION OF PATAPSCO VALLEY STATE PARK

In the 1600s, the Patapsco River Valley was a plentiful hunting ground for American Indians with about 95 percent forested land. Once European settlers arrived, homes and businesses began to emerge in the Patapsco Valley. The harbor of Elkridge Landing was an important colonial port (second only to Annapolis) that served as a gateway to shipping agriculture products, natural resources, and manufactured goods from the Patapsco Valley's plantations and mills. Tobacco became a profitable and main crop for local farmers, resulting in the clearing of a great deal of forested land. Throughout the 19th century, the number and variety of mills increased along the lower Patapsco River. After disastrous floods and fires, the area began to rebuild in the 20th century, with a new emphasis on conservation. In 1907, a new forest reserve was created called Patapsco, with its humble beginnings of 43 acres of the Hilton estate donated by John M. Glenn to the Maryland Board of Forestry. Erosion of soil from the treeless hillsides adjacent to the river began filling it with silt. Reforestation efforts began to help hold soil in place, especially near the newly built Bloede Dam, which provided electric power to nearby communities. The Maryland Board of Forestry hired staff to manage and promote conservation efforts, monitor public activities, and prevent and manage forest fires. Forest wardens were on call 24 hours a day, often assisted by their wives and children. By 1919, the reserve grew to 1,000 acres, 200 campsites, and several miles of nature trails. During the Depression, the modernized state park was equipped with amenities and conservation practices serving nature and the public. By the mid-1930s, the reserve officially became Maryland's first state park. The park's popularity continued to grow until another major flood destroyed most of it in the 1970s. Rebuilding, restoration, and improvements occurred over many years. The family-oriented park and environmental areas of today cover over 20,000 acres spanning eight developed recreational areas along 32 miles of the Patapsco River. Patapsco Valley State Park provides a variety of recreational activities and nature programs for people of all ages.

The Patapsco River Valley in the 1600s was prime hunting grounds for the American Indian Susquehannock, Piscataway and Seneca tribes. Different tribes hunted elk, black bear, bison, deer, and many other forest animals, along with fish, and shellfish. The arrival of foreign colonists to the Patapsco Valley, diseases brought over from other countries, and conflicts between tribes and Colonial Americans reduced the American Indian population, eventually forcing them from the area. (Courtesy of DNR.)

In 1697, Elkridge Landing was a thriving colonial port. Large colonial ships sailed from England up the Patapsco River to the harbor to load tobacco, grain, and pig iron from local businesses. This familiar painting by Joan Hull is a rendition of Elkridge Landing's harbor during the 18th century. (Painting by Joan Hull, courtesy of Mary Catherine Gargano and Elkridge Heritage Society.)

State Forester Fred W. Besley is responsible for introducing professional forestry principles in Maryland. Besley recognized that some forests were more than places to save trees. He opened the Patapsco Forest Reserve for public recreation, devised a highly successful system of fighting fires reducing loss of forest acreage, and inventoried every stand of trees larger than five acres in Maryland. (Courtesy of Maryland Conservation Agency Museum.)

Maryland Forestry and Parks
CENTENNIAL
1906-2006
Celebrating a Century of Conservation and Recreation

Besley Demonstration Campsite

Recreational camping on Maryland's public lands began near this spot about 1916. Maryland's first state forester, Fred W. Besley, encouraged the public to participate in outdoor recreation on state forest lands in an effort to foster an appreciation for forest conservation, and to gain public support for acquiring more forest and park lands. To set an example, Besley and his family camped at the Cascade Falls area of Patapsco State Forest Reserve during the summer months. This site proved an attractive venue for Baltimore City residents, launching the tradition of recreational camping on state forest and park lands.

Dedicated October 10, 2006

This plaque commemorates the Besley family's demonstration campsite where they educated others about roughing it in the outdoors. Campers and other visitors to the park soon developed an appreciation of forest conservation while enjoying outdoor recreation. This plaque is located next to the water fountain, across from the "swinging bridge" in the Orange Grove Area. (Authors' collection.)

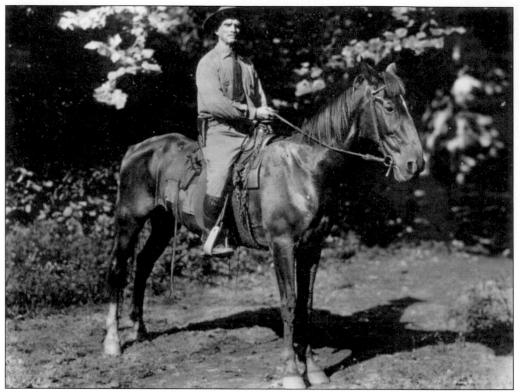

US Cavalry originally protected national parks in the 1800s from poaching and vandalism. When the Maryland Board of Forestry was established in 1906, it created a similar service of forest wardens to deal with forest fires and implement wise forest management practices. Forest warden Edmund Prince is shown above on his horse named Prince. For three decades, Prince regularly patrolled the Patapsco Forest Reserve, on call 24 hours a day on horse and vehicle, ensuring the safety of visitors and park campers, as well as preventing, detecting, and putting out fires. He inspected sanitary conditions at the Patapsco Forest Reserve's campsites and protected the forest property. The privately owned Chevrolet below was outfitted with a fire rake mounted on the front, searchlight, and Indian pump, with additional tools in the back seat. (Both, courtesy of Maryland Conservation Agency Museum.)

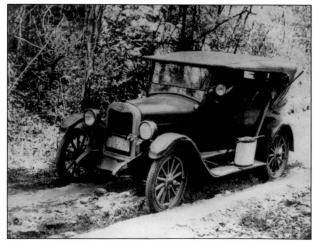

Firefighting tools such as rakes, axes, saws, water-pump tanks, shovels, hoes, brush hooks, and collapsible fire buckets were used for extinguishing small fires by forest warden Edmund Prince and volunteer wardens in the Patapsco Forest Reserve in 1928. State Forester Fred Besley's system of fighting wildfires with volunteer fire wardens reduced the average loss in Maryland from 203 acres per year to only 17. (Courtesy of Maryland Conservation Agency Museum.)

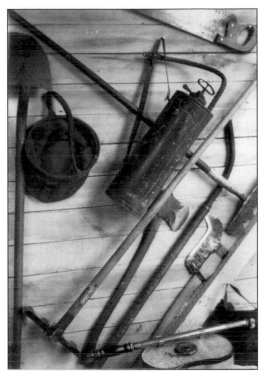

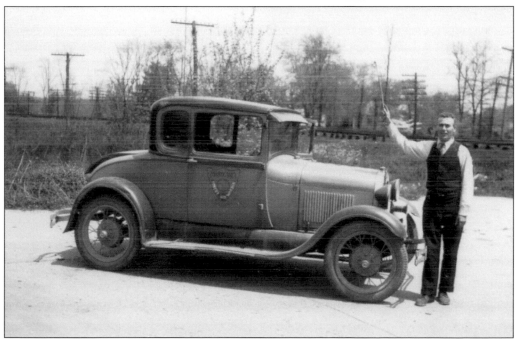

This 1930 Model A Ford was used by Maryland forest wardens. They were paid $20 a year for their services and expenses. For putting out forest fires, wardens received $1.50 for five hours or less and 25¢ per hour thereafter. They had authority to arrest and prosecute persons for violations of any of the forest laws, rules, or regulations for the protection of the state forestry reserves. (Courtesy of Maryland Conservation Agency Museum.)

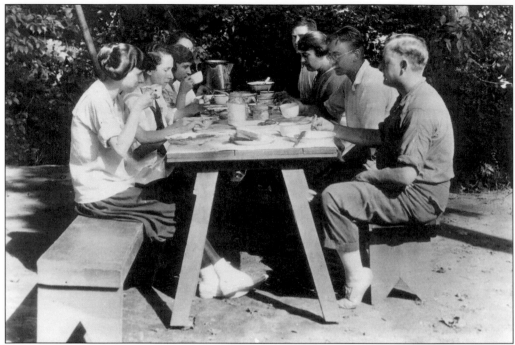

Family and friends enjoy a picnic lunch while camping at Camp Vineyard in 1921 in the Patapsco Forest Reserve. While these folks are dressed comfortably in leisure clothes, when the reserve first opened, others came to the park often dressed up in more formal apparel, wearing dresses and ties. Picnicking continues to be one of the most popular activities in the park today. (Courtesy of Maryland Conservation Agency Museum.)

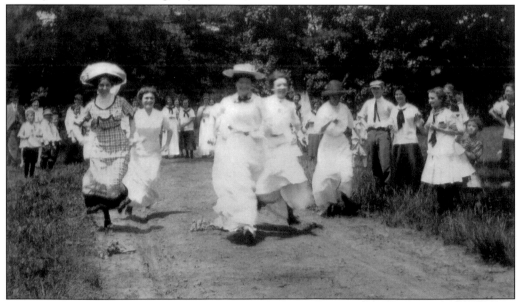

In the early 20th century, park visitors came by car or train for a day's outing for swimming, picnicking, fishing, or just a stroll in the park. Participants in this women's race during a 1911 picnic look enthusiastic, but running must have been a little difficult considering the dress of the day. (Courtesy of the Catonsville Room, Baltimore County Public Library.)

State Forester Fred Besley encouraged the public to picnic and camp at the Patapsco Forest Reserve, and the public soon began referring to it as Patapsco Park. By 1912, a portion of that forest/park had been developed and dedicated specifically for public recreational use. Campers, picnickers, and swimmers flocked out of Baltimore to spend time alongside the Patapsco River escaping the summer heat. Families and even business groups set up camps for up to six months where the campers would, according to Besley, "rough it pleasantly." (Both, courtesy of DNR.)

SPECIAL POSTERS FOR PATAPSCO RESERVE.

(Sign prepared and posted in co-operation with the Baltimore and Ohio Railroad.)

PATAPSCO PARK

STATE FOREST RESERVE

Attractive Camping Sites

NEAR HERE

FREE UPON APPLICATION

State Forester, Baltimore Forest Patrolman, Oella

Or Local Agent
Baltimore & Ohio R. R.

(Sign posted to conform with a recent ruling of the Board of Forestry.)

NO HUNTING!

FIREARMS PROHIBITED
————

PATAPSCO STATE PARK

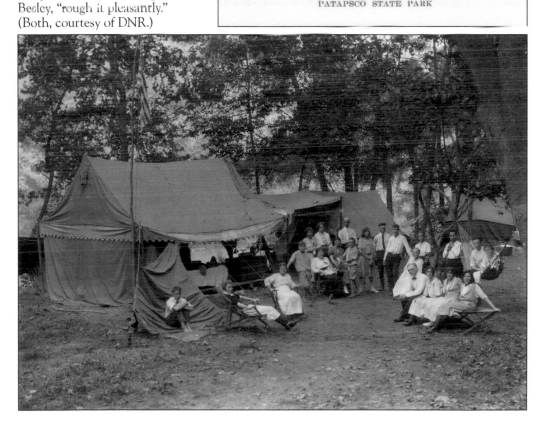

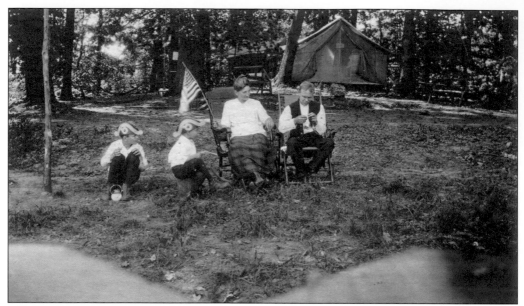

The Andrews family (Al, Walt, Eugenia W. "Ma," and Frank W. "Pa" Andrews) are pictured camping in 1918 at the Hill Top Camp. Pa lit Japanese firecrackers in celebration of the Fourth of July. The Andrews family took advantage of the Patapsco Forest Reserve, setting up several camp areas over the years in the area formerly known as Camp Hill Top in today's Glen Artney area. (Photograph by J. Frank Andrews, courtesy of Ruth Andrews Sherwood.)

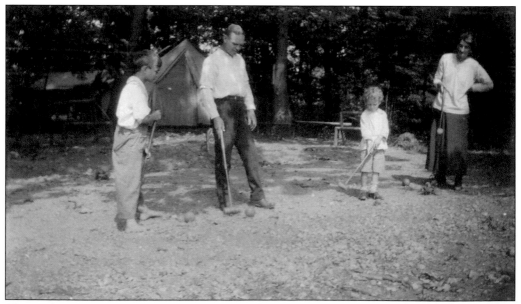

The Andrews family and other visitors enjoyed playing croquet, where wooden balls were knocked through metal wickets with mallets. Another popular camper game was quoits, which is similar to horseshoes. (Photograph by J. Frank Andrews, courtesy of Ruth Andrews Sherwood.)

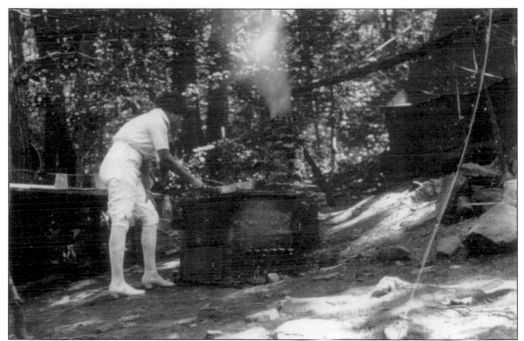

Women would bring things from home to make outdoor living more like home. Above, Lee Elmer-Hamilton cooks on a metal stove brought to her family's seasonal camp. Families could camp free of charge if they dug their own latrine and obeyed the strict fire laws. Campfires, outdoor cooking, and just relaxing in a hammock in the cooler Patapsco Forest Reserve were regular activities when visitors came to enjoy a little rest and relaxation. By the end of the 1920s, the area open to the public grew to almost 1,000 acres, 200 campsites, and several miles of nature trails, and was shared in ownership by the park and the City of Baltimore. (Both, courtesy of DNR.)

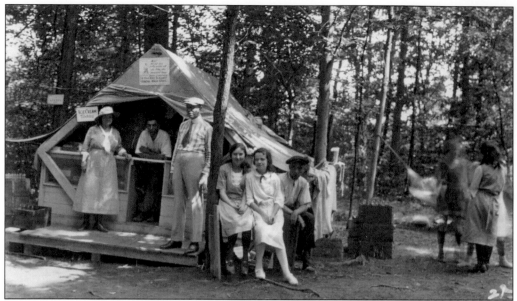

The Hutzler Brothers Department Store in Baltimore City reserved dozens of camp sites for its employees and their families. Many of the Hutzler employees commuted daily to work, while their families stayed to enjoy the park. To foster camaraderie and loyalty, the sites were in close proximity to one another. A commissary was available, and to the delight of the campers, ice cream was delivered once a week. (Courtesy of DNR.)

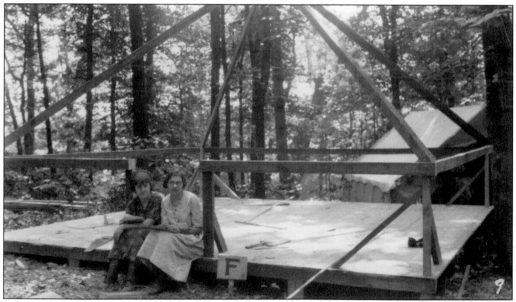

These two Hutzler employee family members await the setting up of their tent. Many campers at the Patapsco Forest Reserve utilized canvas World War I Army surplus tents over wooden frames and a wooden floor. Many campers even had electricity wired in for lighting and radios. Groceries and other necessities were often purchased in the nearby mill town of Thistle. (Courtesy of DNR.)

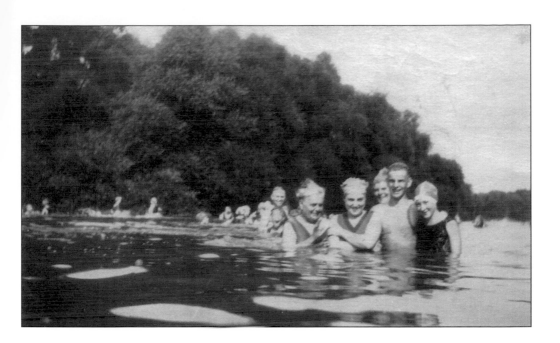

Above, swimming in the Patapsco River about a mile above the Avalon Dam in 1921, are the Andrews family and their friends. the Barretts They noted that "there were often over 100 people there on Saturdays and Sundays, and the water was clean and pure." The deeper water in the Patapsco River was attributed to the mill dams along the river. The area near Ilchester Bridge was another popular swimming area, where many people continue to enjoy the river today. Pictured below are Hutzler campers swimming. (Above, photograph by J. Frank Andrews, courtesy of Ruth Andrews Sherwood; below, courtesy of Maryland Conservation Agency Museum.)

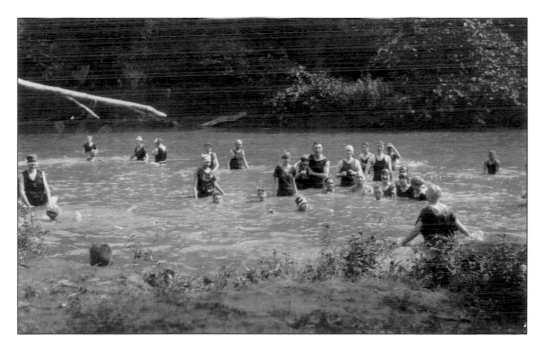

New picnic areas along River Road in 1942 attracted more people to the Orange Grove area. Utilization of the park and appreciation of its natural resources continued to expand into the 1950s and 1960s as visitors discovered the natural beauty of Patapsco State Park. This expansion, to a large extent, was due to the efforts of Karl Pfeiffer, a longtime assistant state forester, known as "Mr. Patapsco." (Courtesy of DNR.)

A volunteer rescue squad of park employees was formed at Patapsco State Park in the early 1970s. They were trained and equipped for emergency situations in a variety of rough terrain. Climbing and first aid were essential parts of their training. (Courtesy of the Catonsville Room, Baltimore County Public Library.)

Two

AVALON

The Avalon area of Patapsco Valley State Park is filled with major "firsts" and significant history. In the 1700s, tobacco and pig iron were key products produced by colonists that were exported from nearby Elkridge Landing, developing the harbor into a busy Maryland shipping port; the Marquis de Lafayette rushed his forces toward Virginia to aid General Washington in forcing British general Charles Cornwallis to surrender, while crossing what used to be the "raging Patapsco River" (one scow sank, and nine soldiers drowned). During the 1700s and 1800s, several mills were built nearby along the river. Dorsey's Forge, Hockey Forge, and the Elkridge Furnace reportedly produced metal musket parts to aid in the American Revolution. Dorsey's Forge later expanded and became a successful iron and nail works, the genesis of a new mill town called Avalon. The engineering marvel and landmark Thomas Viaduct was constructed by the Baltimore & Ohio (B&O) Railroad for train connection to Washington, DC. Upon its completion in 1835, it was considered the largest bridge in the country as well as the first curved multi-span masonry railroad bridge. Union camps were stationed on both sides of the Thomas Viaduct during the Civil War to guard against the Confederate army and local Southern sympathizers. In the early 1900s, the Baltimore County Water and Electric Company provided drinking water to surrounding communities. During the Great Depression, a Civilian Conservation Corps camp was built and operated to reforest and expand the park, including building stone picnic shelters, roads, and trails. During World War II, this same camp housed conscientious objectors who continued the conservation work. Even with damaging floods that destroyed remnants of the past, Avalon continues to thrive and be enjoyed by visitors with the help of park staff and volunteers. Interpretive signs and remnants of the past may be found throughout the park to provide clues to the area's rich history.

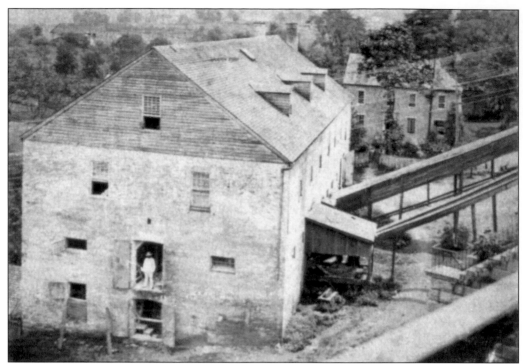

G.W. Levering and Company began operations with a replacement gristmill in 1857 until the building burned in 1883. The pictured Hockley Mill was adjacent to parkland just downriver of the Thomas Viaduct. The building also served as a whiskey distillery and later manufactured telephone, telegraph, and electric light supplies. Shown behind the mill is the Chantilly House, reportedly the former home of Horatio Johnson, the inspector of tobacco at Elk Ridge Landing. (Courtesy of F. Brennan Harrington and John Grain.)

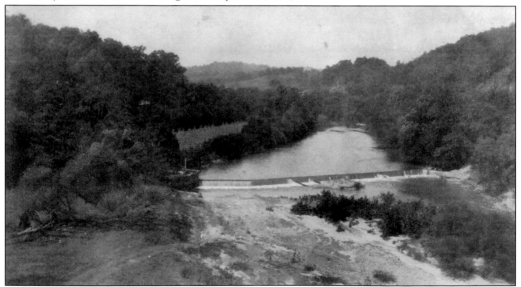

The Hockley Dam was the first dam built on the lower Patapsco River. The dam and millrace provided waterpower to the mill and was essential in the industrial development along the river. This c. 1917 postcard gives a view from the old bridge along Gun Road. (Courtesy of William Hollifield.)

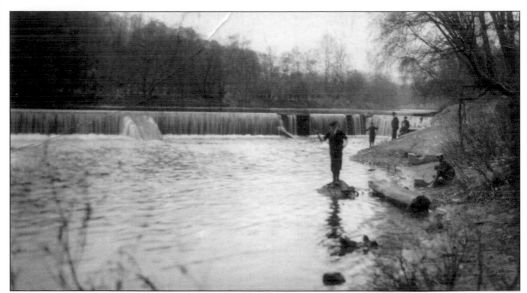

Fishing just below the Hockley Dam was popular in the 1920s. The remaining dams left behind in the park (after industry along the river ended) have been removed or are planned for removal. Although formerly a favorite fishing area, the dam inhibited the dispersal of plants and nutrients downstream, impeding the migration of fish and other wildlife. See chapter five for other reasons for dam removal. (Courtesy of DNR.)

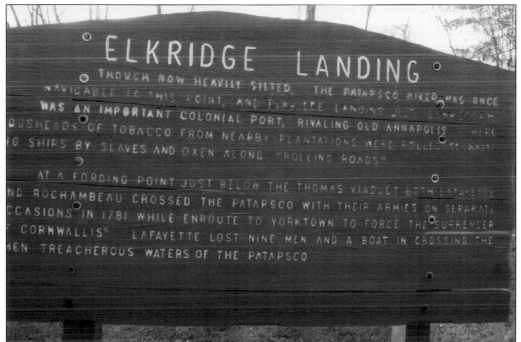

Over the years, simple signs were erected throughout the park to describe the area's history, but many were washed away in 1972 by Tropical Storm Agnes. The believed location of Lafayette's harrowing river crossing experience was in close proximity to Elkridge Landing. General Lafayette's and General Rochambeau's troops separately crossed the Patapsco River transporting war materials to Virginia to help force the surrender of Cornwallis. (Courtesy of DNR.)

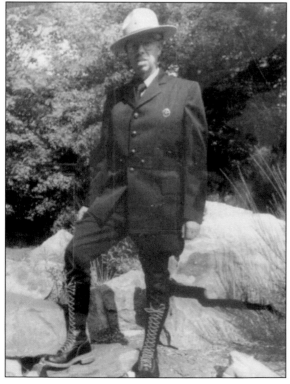

This original duplex structure housed several families together in the former Avalon Mill town, which survived the 1868 flood. Restoration work began in 1992, and other renovations continue for the visitor's center. The center is named in honor of former park naturalist William Offutt Johnson, for his many years of outstanding service and dedication to the renovation of the visitor's center. (Photograph by Al Plitt, courtesy of DNR.)

Park naturalist William Offutt Johnson had a distinguished 35-year DNR career and retired in 2001. He is pictured here in early Maryland forest ranger attire. Johnson was a longtime park naturalist and assistant director of Program Open Space, where he worked in preserving open space in Maryland. Johnson effectively connected people with the outdoors. This dedicated protector of the environment died in 2013. (Courtesy of DNR.)

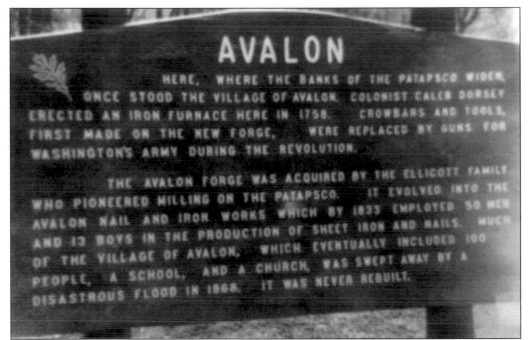

AVALON

HERE, WHERE THE BANKS OF THE PATAPSCO WIDEN, ONCE STOOD THE VILLAGE OF AVALON. COLONIST CALEB DORSEY ERECTED AN IRON FURNACE HERE IN 1758. CROWBARS AND TOOLS, FIRST MADE ON THE NEW FORGE, WERE REPLACED BY GUNS FOR WASHINGTON'S ARMY DURING THE REVOLUTION.

THE AVALON FORGE WAS ACQUIRED BY THE ELLICOTT FAMILY WHO PIONEERED MILLING ON THE PATAPSCO. IT EVOLVED INTO THE AVALON NAIL AND IRON WORKS WHICH BY 1833 EMPLOYED 50 MEN AND 13 BOYS IN THE PRODUCTION OF SHEET IRON AND NAILS. MUCH OF THE VILLAGE OF AVALON, WHICH EVENTUALLY INCLUDED 100 PEOPLE, A SCHOOL, AND A CHURCH, WAS SWEPT AWAY BY A DISASTROUS FLOOD IN 1868. IT WAS NEVER REBUILT.

This former park sign explained the rich history of the area. Although forbidden to manufacture finished products by English law in the Colonies, Dorsey's Forge manufactured crowbars. Later, it was reported they manufactured weapons and other paraphernalia to support the American militia. The Ellicott family later purchased Dorsey's Forge, renaming it the Avalon Nail and Iron Works, where rails for the B&O Railroad were produced. These industries helped win American independence and ignite Maryland's industrialization. (Courtesy of DNR.)

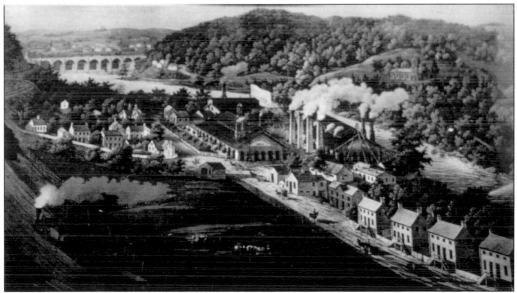

The successful Avalon Nail and Iron Works (1815–1868) evolved from the former Dorsey's Forge. As the mill expanded, a new mill town was built, named Avalon by the Ellicott family. This mill once produced 44,000 kegs of nails a year, stamping out 1,200 nails per minute. The second house from the left is now the restored visitor's center. (Courtesy of DNR.)

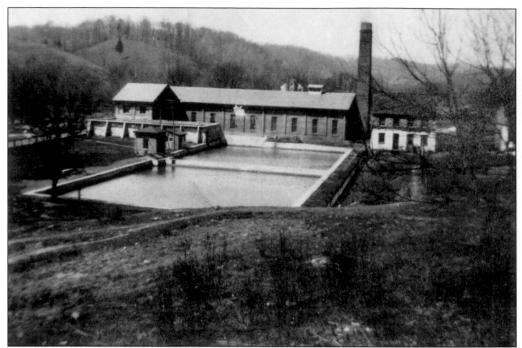

From 1910 to 1928, a water filtration plant operated on the former Avalon Nail and Iron Works site. A dam, pumping stations, and a canal were built upriver from the plant. Water from the river was channeled down the millrace into the filtration plant for purifying, and then pumped into nearby communities. The building once housed park maintenance operations before the 1972 flood. Remnants of the concrete holding ponds and pumping station complex are still visible. (Courtesy of DNR.)

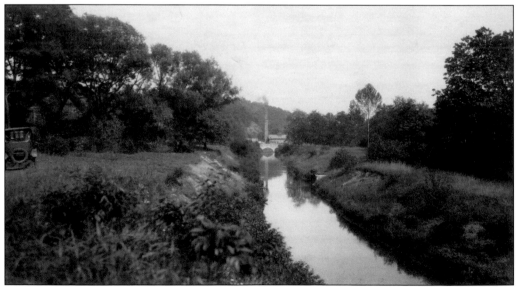

This small stream was once an active millrace that brought water from the mill pond (now Lost Lake), under the Gun Road bridge to the Avalon Nail and Iron Works in the 1800s and, later, to Victor Bloede's Baltimore County Water and Electric Company (1910–1928). The millrace no longer holds water except after a major rain. (Courtesy of DNR.)

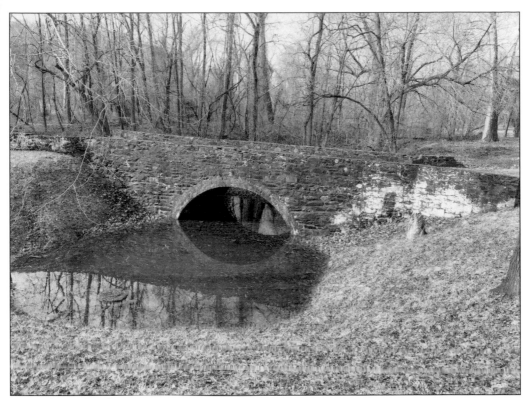

The old Gun Road stone arch bridge spans the old millrace, which supplied water to the Avalon Nail and Iron Works. Gun Road was renamed (from Avalon Forge Road) for the guns reportedly produced at the Dorsey's Forge that were transported to Elkridge Landing and shipped down the river to Annapolis for final assembly and, most likely, for the Civil War artillery position upriver close to the Thomas Viaduct. (Authors' collection.)

This steel bridge once crossed the Patapsco River over Gun Road. Destroyed by Tropical Storm Agnes, the only trace of it is the old stone abutment. A modern paved roadway now crosses the river, connecting visitors from Baltimore County to Howard County heading to the Orange Grove area of the park. (Photograph by Ray Cain, courtesy of the Catonsville Room, Baltimore County Public Library.)

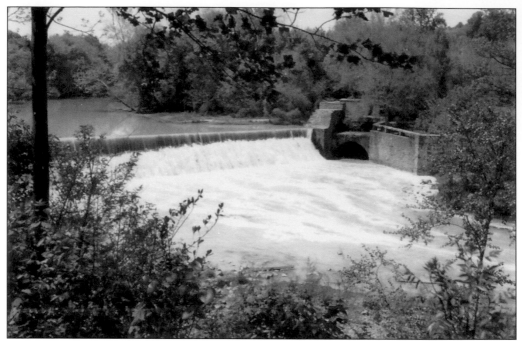

Inadequate water supply services and demand for cleaner drinking water compelled local engineer and entrepreneur Victor Bloede to organize a county water and electric company in 1909, utilizing the site of the abandoned Avalon Nail and Iron Works. The refurbished Avalon Dam supplied water from the Patapsco River to the Baltimore County Water and Electric Company from 1910 to 1928 for the industries, businesses, and residences of southwest Baltimore and southern Baltimore County. The Patapsco State Forest Reserve provided forest protection and erosion control to ensure constant and regulated waterpower. The crumbling stone wall below is the last remnant of the original dam. (Above, courtesy of Al Plitt/DNR; below, authors' collection.)

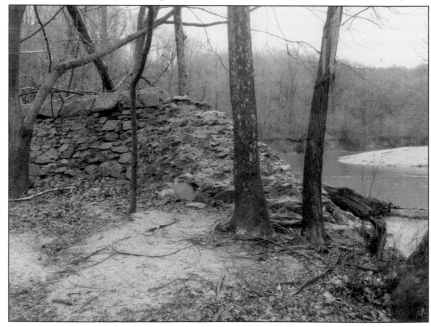

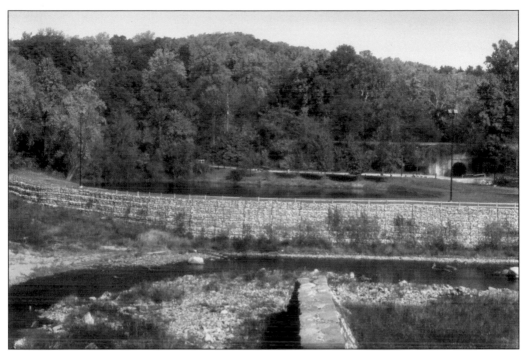

During the devastating tropical storm in 1972, the river diverted itself around the north side of the remaining wall of the Avalon Dam shown at the bottom of this photograph. After the flood, environmental upgrades and other restoration work were completed in the 1980s in the Lost Lake area. A new retaining wall was built above the diverted section of the river just beyond the remains of the Avalon Dam. (Courtesy of DNR.)

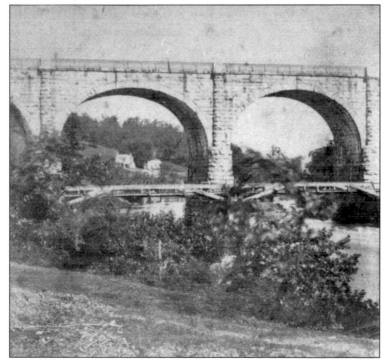

Construction on the Thomas Viaduct began in 1833, and it was completed in 1835. A footbridge just below the Thomas Viaduct is seen in this late 1800 stereograph. The high waters from the 1868 flood most likely destroyed the footbridge. (Courtesy of Dan Toomey.)

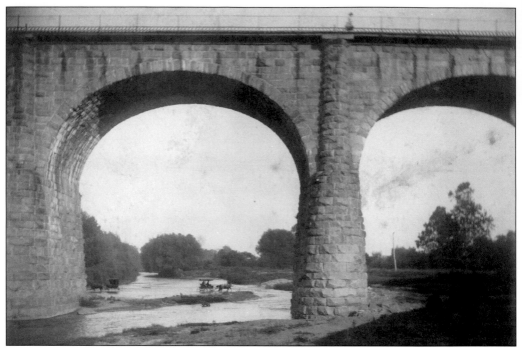

Several sections of the Patapsco River in the park are shallow enough to allow visitors to wade across. This 1886 photograph shows a river crossing near the Thomas Viaduct most likely in the summer when the water is usually at its lowest level. Today's viaduct appears to be significantly shorter due to sediment buildup over the years. (Courtesy of Howard County Historical Society.)

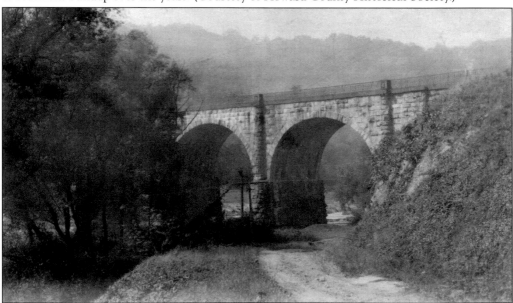

This postcard shows the massive granite Thomas Viaduct train bridge in its heyday. A dirt roadway passed under the first arch on the Baltimore County side (right). Now paved, the road serves as the entrance to Patapsco Valley State Park's Avalon area, off South Street in Relay. Park visitors are treated to a close-up view of the only National Historic Landmark in the park when traveling under this engineering wonder. (Courtesy of William Hollifield.)

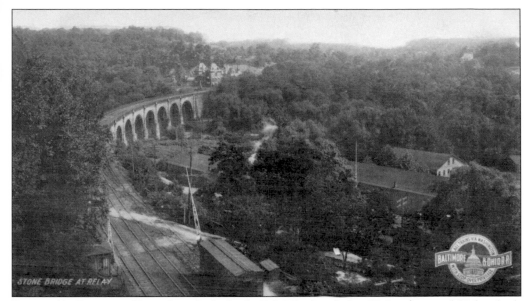

Designed by Benjamin Henry Latrobe Jr. for the B&O Railroad, the 612-foot-long and 60-foot-high Thomas Viaduct was built on a curve with eight Roman arches. Approximately 63,000 tons of locally quarried granite were brought by rail and hoisted up with ropes and pulleys. Note the old Levering Avenue grade crossing, the Hockley Mill complex to the right, and the Viaduct Hotel in the distance. (Courtesy of Dan Toomey.)

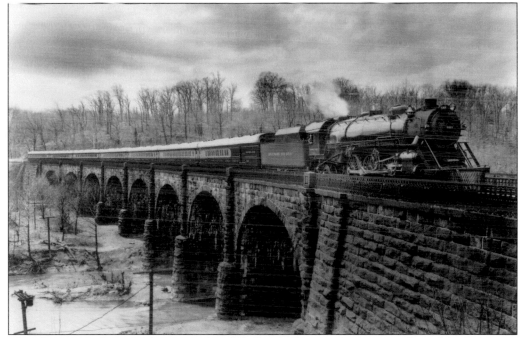

The Thomas Viaduct was the namesake of Phillip E. Thomas, the first president of the Baltimore & Ohio Railroad. This unique bridge has become an enduring symbol of the B&O Railroad and the Patapsco Valley, withstanding time, numerous floods, and the weight of not only the first steam locomotives, but modern-day trains. Trains were frequently posed on the bridge for promotional photographs. (Courtesy of B&O Railroad Museum Archives.)

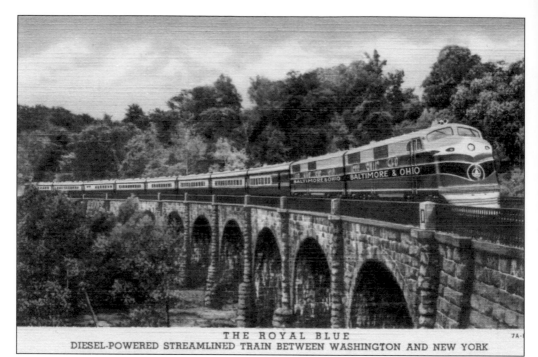

THE ROYAL BLUE
DIESEL-POWERED STREAMLINED TRAIN BETWEEN WASHINGTON AND NEW YORK

7A-1

As early as 1837, B&O trains traveled between Baltimore and Washington, DC. This important link aided the development of transportation, communication, and commerce. The picture postcard above shows the famed Royal Blue Line. It was the B&O Railroad's signature passenger line that crossed the Thomas Viaduct on its way from Washington to New York from the 1880s to the 1950s. Below is the B&O's *Columbian*, which was launched on May 24, 1931, operating with heavyweight equipment and advertised as the first train in the country with air conditioning. Both of these trains traveled through the Patapsco Valley. (Above, courtesy of William Hollifield; below, courtesy of John McGrain.)

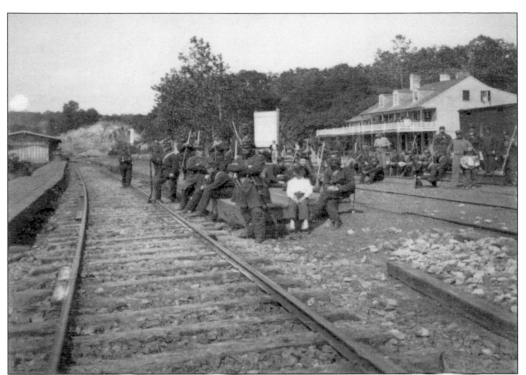

During the Civil War, besieged Washington, DC, was surrounded by the Confederate state of Virginia and Confederate-sympathizing portions of Maryland. The B&O was the only rail link from Washington to the rest of the Union for troops and supplies. There was only one telegraph line from Washington to communicate with the rest of the Union. Both of these crossed the Patapsco River over the vulnerable Thomas Viaduct. It was guarded by the Union army throughout the war. The pictured Relay House became headquarters. One encampment, Fort Dix, was located in Relay on the northern side of the Thomas Viaduct. A second, Camp Essex, was located on the southern side in Elkridge. The cannons at right were located just west of the Relay House, pointing toward Ellicott Mills. (Both, courtesy of Dan Toomey.)

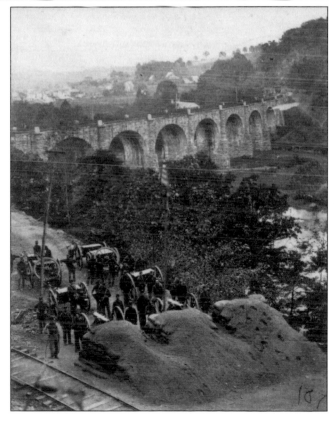

During the Great Depression, the Maryland Department of Forestry hired unemployed men to work in the Patapsco Forest Reserve. These men are taking a lunch break while doing conservation work. This program began in 1932 and was phased out, replaced by Pres. Franklin Roosevelt's New Deal Program. Beginning in 1933, federal money and additional labor poured into Maryland, enhancing public parks and forests. Improvements included drinking water, restrooms, pavilions, cabins, campgrounds, access roads, reforestation, and more. The formation of the Civilian Conservation Corps (CCC) would later build Camp Tydings (named after Maryland senator Millard E. Tydings) at Patapsco Valley State Park to house its corpsmen. (Both, courtesy of DNR.)

The first Camp Tydings was located on the Howard County side of the river. The entire camp was washed away by flood waters in August 1933. This photograph shows the temporary tent camp built after the flood on higher ground on the Baltimore County side near Gun Road. The US Army later brought 600 tons of dirt to level it for the construction of more permanent wooden barracks. (Courtesy of DNR.)

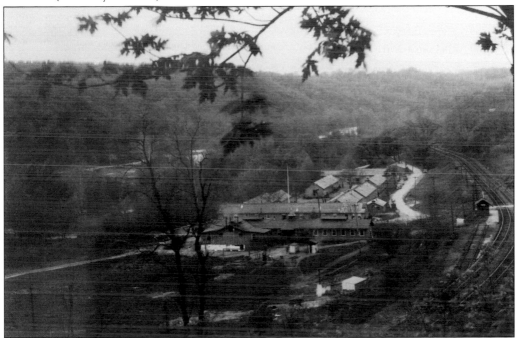

Organized during the Great Depression, the Civilian Conservation Corps was sometimes called "Roosevelt's Tree Army." CCC men received $30 a month ($25 was sent home to support their families). They benefited from educational, nutritional, and recreational programs, as well as developing self-pride as they worked for the national good. This photograph shows Camp Tydings. (Courtesy of DNR.)

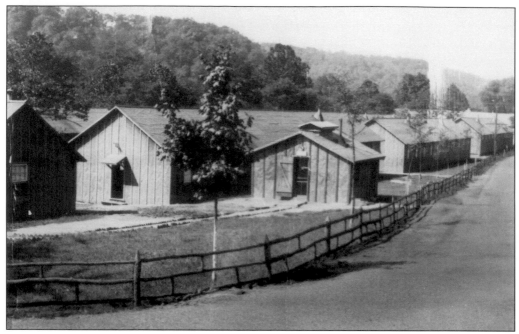

From June 1933 until April 1938, the 356th Company of the CCC was stationed at Camp Tydings. The camp included a mess hall, dispensary, recreation hall, shower buildings, latrine, headquarters building, and five 40-man barracks. The buildings were of pine lumber covered with tar paper held in place with wood strips. The buildings were constructed in four-foot sections for easy relocation. Approximately 200 men worked on reforestation, fire prevention, picnic areas, campground facilities, trail development, and road construction annually. This section of the camp was located off Gun and Glen Artney Roads. Only a few concrete sidewalks, steps, a partial stone foundation, and a fireplace mark the site of the camp. (Above, courtesy of Maryland Conservation Agency Museum; below, courtesy of DNR.)

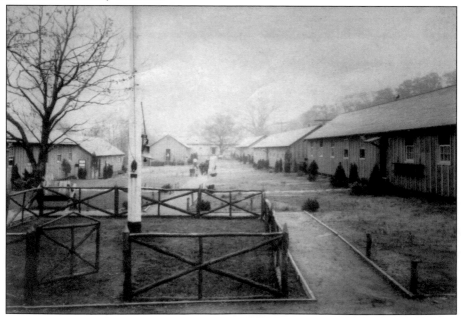

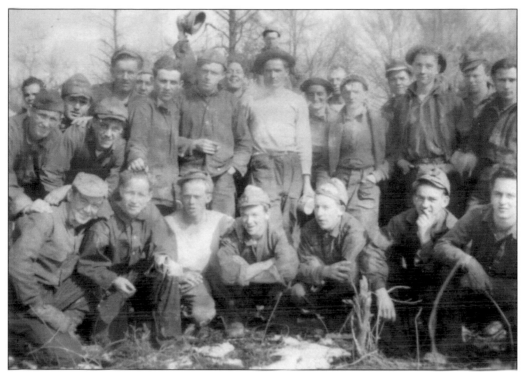

CCC men wore military type uniforms. They were primarily single men between the ages of 17 and 23. Lodging, meals, clothing, and medical and dental care were free, and continuing education classes were available in the evenings. Corpsmen worked every day except Sunday, with evenings free for leisure activities. Proud of the work they did as part of the Civilian Conservation Corps, corpsmen often wore their dress uniforms when going into town. Many of the men formed life-long friendships with their colleagues and remained in the area. (Both photographs by Russell Ridgely, courtesy of DNR.)

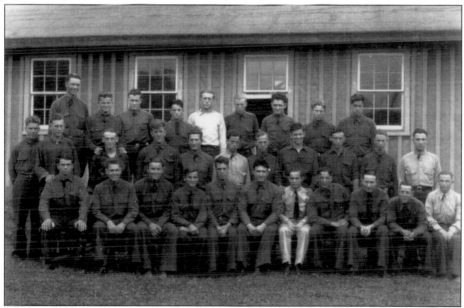

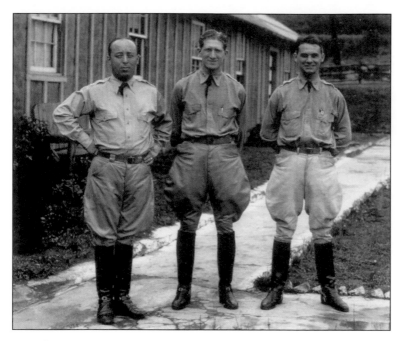

Although several federal agencies would be involved, the CCC was administered by the US Army. Life in a CCC camp resembled the regimented life on a military base of the time. These US Army Camp Tydings officers are (from left to right) Capt. Sam Glazier, commanding officer; Lt. Charles Stein, medical officer; and Lt. Earl Parker, mess officer. (Courtesy of DNR.)

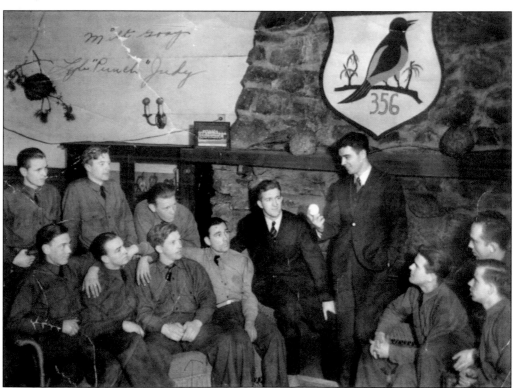

Baltimore Orioles baseball players Milt Gray (standing) and Lyle Judy (seated in suit) visit Company 356 of the CCC at Camp Tydings in the recreation hall in 1937. Notice the fireplace, which still remains in Shelter 1 in the Avalon area of the park. Company 336 was also stationed at Camp Tydings for conservation work in the park during the 1930s. (Courtesy of DNR.)

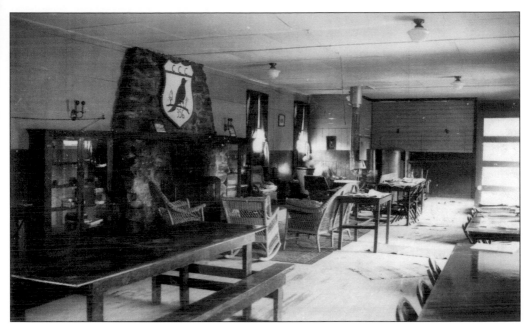

The dining/recreational hall used by the Civilian Conservation Corps was a popular place for recreational activities after work and the weekends. Where Camp Tydings once stood, a few stone remnants still stand that survived floods and time. The original fireplace chimney from the dining/recreational hall was integrated into today's Avalon Shelter 1. After the United States became involved in World War II, the CCC camp was converted into the first US Civilian Public Service Program camp on May 14, 1941—an alternative to drafted military service for conscientious objectors. Conservation projects were conducted from May 1941 to August 1942. Participants were not paid for their work but were sponsored by a local Quaker group. Local protests and public pressure closed the camp. (Above, courtesy of DNR; below, authors' collection.)

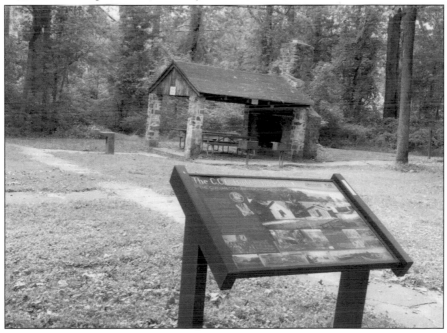

During the Civilian Conservation Corps' existence (1933–1938), it had the largest fleet of trucks of any organization in the United States. Working in CCC camps demanded strong physical strength to accomplish park and conservation projects such as planting trees, quarrying stone, crushing rocks, and improving roads. (Courtesy of DNR.)

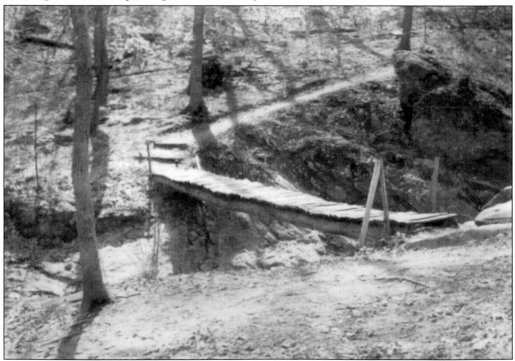

Pictured is a footbridge over one of the streams in Patapsco Valley State Park, built by the Civilian Conservation Corps in the 1930s. (Photograph by Dave Ditman, courtesy of DNR.)

Three

ORANGE GROVE

The Orange Grove area of the park was once prime Indian hunting ground. It is named for the small company-owned village that once existed here. Factory workers would cross the wobbly suspension bridge over the Patapsco River (now referred to as the swinging bridge) to get to the Orange Grove Flour Mill run by C.A. Gambrill Manufacturing Company. In the early 1900s, there were 22 adults and 19 children. Eleven families lived in houses, along with a combination church and school. Additional help to run the mill was drawn from neighboring areas—they arrived by foot or rail. The brand Patapsco Superlative Flour was produced at the mill. This flour was transported not only to nearby communities, but throughout the country and around the world via truck, railroad, and ship. The establishment of the historic Bloede hydroelectric dam produced conservation efforts to protect it from the effects of silting and other erosion damage. The Patapsco Forest Reserve was established and staffed to enhance the forest and manage public use, establishing Maryland's first state park. The popularity of the forest reserve for public use was realized at Orange Grove in the 1920s. Family campsites were numerous as the people escaped the heat of the cities in the summertime and connected with nature, hiking and finding the breathtaking Marlburg Falls, known today as Cascade Falls. The Great Depression in the 1930s marked the establishment of conservation actions that repaired the damage to the landscape from man and floods, converting Patapsco into a modern state park with facilities and amenities for the public. River Road was once a busy thoroughfare through Orange Grove, connecting Elkridge to Ellicott City. Patapsco Valley State Park headquarters was located here until devastating floods in the 1970s destroyed the remains of the mill town and most of the park. Recovery and rebuilding took many years. Today, this area of the family-oriented park is highly utilized by park patrons who come for a variety of recreational experiences.

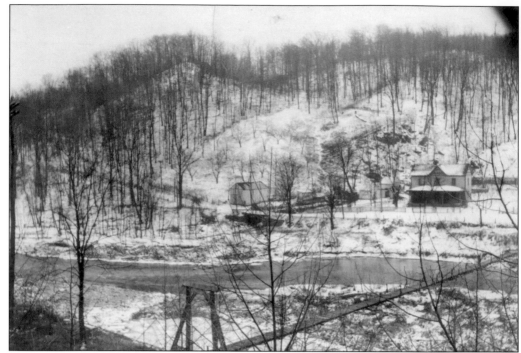

This is a picturesque winter view of a company-owned town in the late 1800s known as Orange Grove. Workers of the Orange Grove Flour Mill and their families lived in houses on the opposite side of the Patapsco River in Howard County, walking to work across the suspension bridge. John Bathgate, the night engineer, and his wife, Augusta, lived in the house shown at right above. In 1904, the area experienced a hard winter. The picture below was taken after sheets of floating ice tore away the swinging bridge and damaged the dam. The company's superintendent and his family lived in the small house in front of the Orange Grove Mill. (Above, courtesy of DNR; below, courtesy of Baltimore County Public Library.)

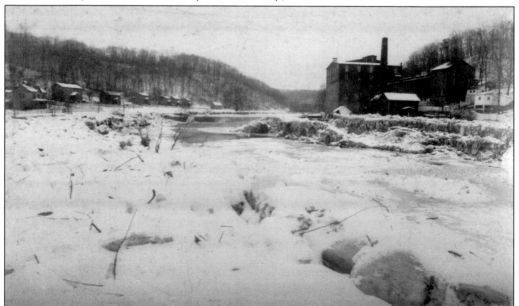

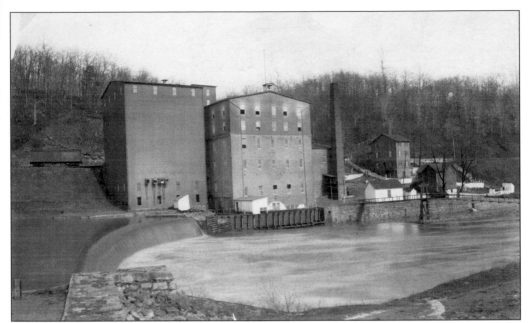

The Orange Grove Flour Mill of the C.A. Gambrill Manufacturing Company operated from 1856 to 1905. It manufactured nine types of flour, including Patapsco Superlative, producing 1,200–1,500 barrels daily. At the turn of the 20th century, it was said to be one of the most productive flour mills east of Minneapolis. A 10-foot-high dam provided waterpower to the mill until the arrival of the steam engine in the 1870s. (Courtesy of DNR.)

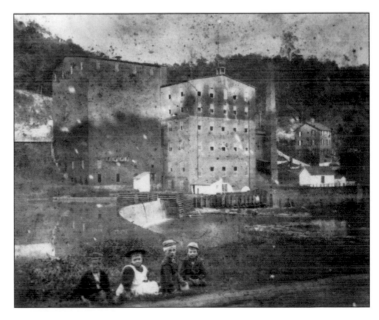

The boy wearing a bandage around his head from an alleged stone-throwing incident is Corliss Clayton. His father, William Clayton, was the mill's stationary engineer, who worked closely with the Corliss steam engine. The family stated that his devotion to the new invention was so strong that he named his son after it. This steam engine greatly reduced the need for waterpower from the river to operate the mill. (Courtesy of DNR.)

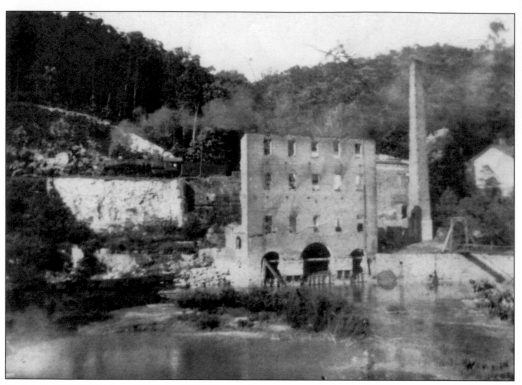

A fire in 1905 permanently closed the Orange Grove Flour Mill. This photograph, taken a short time after the fire, shows the remains of the deserted mill. (Courtesy of DNR.)

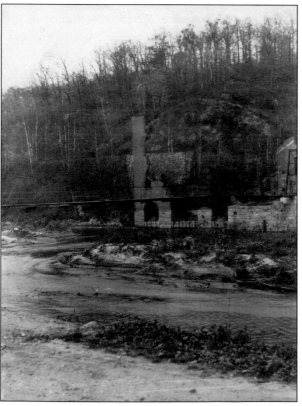

This photograph, taken in 1924, shows the gradual deterioration of the remnants of the Orange Grove Flour Mill. Most of these remnants were later removed by subsequent floods such as Tropical Storm Agnes in 1972. The paved Grist Mill Trail now extends through the mill site and provides park patrons a close-up view of remaining remnants and an informational display about the history of the mill and its workers. (Courtesy of DNR.)

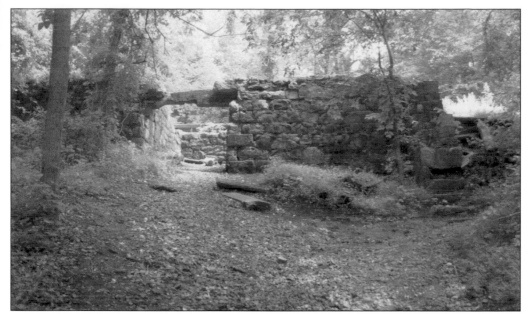

The remains of the coal chute (above where the Corliss steam engine was once located) can be seen today at the back wall of the mill facing the railroad tracks. Grain was transported in railroad boxcars and aligned on the fourth floor of the six-story complex for shipping. Few remnants are left of the complex. (Authors' collection.)

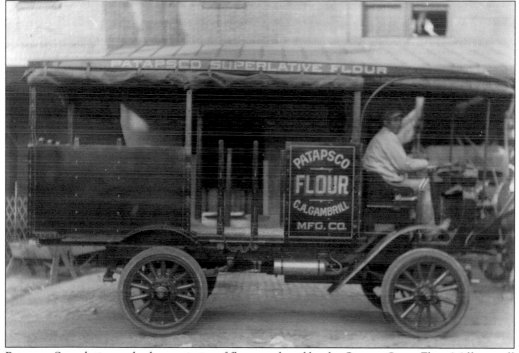

Patapsco Superlative and other varieties of flour produced by the Orange Grove Flour Mill, as well as the other two C.A. Gambrill Manufacturing mills (in Ellicott City and Baltimore City), were transported by truck and railroad to Baltimore Harbor for shipping all over the world. (Courtesy of the Catonsville Room, Baltimore County Public Library.)

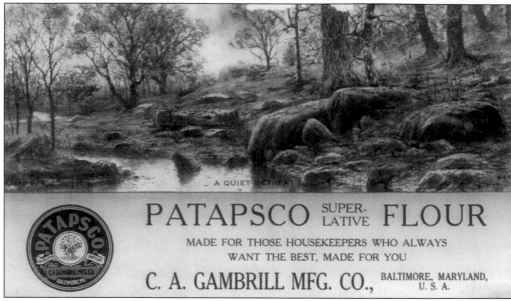

PATAPSCO SUPER-LATIVE **FLOUR**

MADE FOR THOSE HOUSEKEEPERS WHO ALWAYS
WANT THE BEST, MADE FOR YOU

C. A. GAMBRILL MFG. CO., BALTIMORE, MARYLAND, U. S. A.

This is a late-19th-century promotional blotter produced by the C.A. Gambrill Manufacturing Company. The picturesque scene is representative of the view of the Patapsco Valley where Patapsco Superlative Flour was made at the Orange Grove Flour Mill. Similar views still exist along the river today. (Courtesy of DNR.)

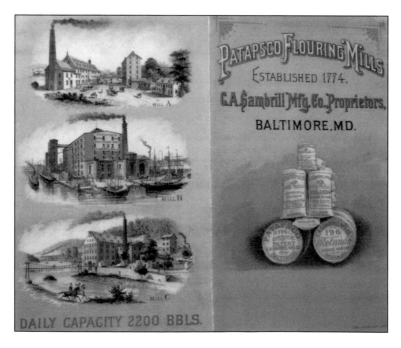

This late-19th-century promotional brochure produced by the C.A. Gambrill Manufacturing Company shows the location of the three flour mills: Mill A in Ellicott City, Mill B in Baltimore, and Mill C in Orange Grove. (Courtesy of John McGrain.)

46

The Orange Grove railroad station adjacent to the mill allowed villagers easy access to inexpensive rail transportation westward to Ellicott City or eastward to Baltimore. It was the closest stop to transport some mill employees in nearby towns to the Orange Grove Flour Mill and local children to the school in the Orange Grove community. (Courtesy of John McGrain.)

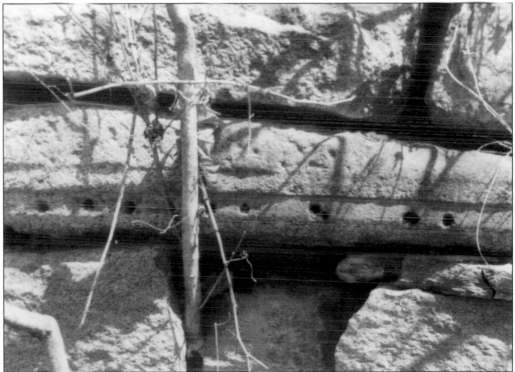

Granite stringers were chosen by the Baltimore & Ohio Railroad in 1828 as the first miles of track were laid. Holes were usually drilled about 18 inches apart where the wooden rails were attached to them. These stringers enabled horses to pull the trains during the early years. After converting to creosote-treated lumber after the Civil War, the original stringers were recycled for use as part of the retaining walls of local mills. Visitors can still see these stringers along the Grist Mill Trail as part of the railroad's retaining walls and former buildings. (Authors' collection.)

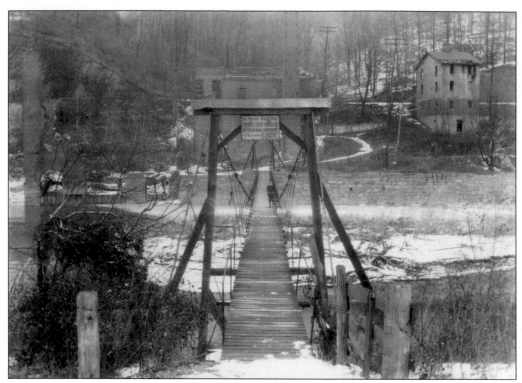

Although the mill was built in 1856, the bridge was not constructed until 1859. The first suspension bridge enabled mill workers living on the Howard County side to cross the Patapsco River to work in the Orange Grove Flour Mill on the Baltimore County side. It saved them a five-mile trek to and from work. The March 7, 1920, winter photograph above shows the remains of the burned out Orange Grove Flour Mill. During the spring, summer, and early fall, forest vegetation obscures the view across the river (below). (Both, courtesy of Maryland Conservation Agency Museum.)

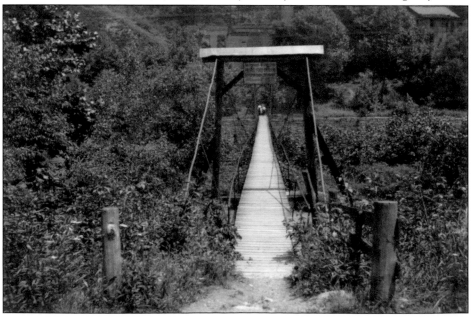

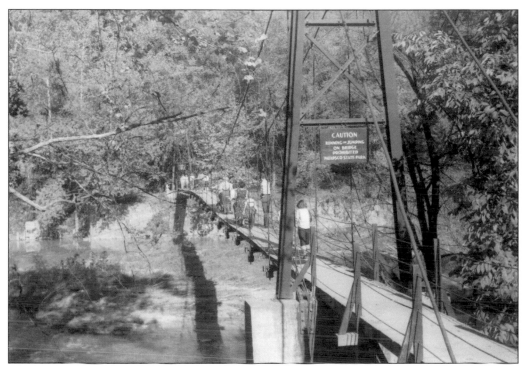

One of the greatest attractions in Orange Grove is the swinging bridge. Millions of park visitors have crossed the Patapsco River over this footbridge. At one time, the swinging bridge used to actually swing from side to side with a little help from the walking public. Although today it no longer swings, it still shakes—it is not suggested for visitors fearful of heights. Over the years, the bridge has been replaced several times. Some of the bridge calamities included a major flood in 1868, an ice flow in 1904, a total of 42 boys jumping on it in 1925, raging floodwaters in 1933 and 1972, and moorings of a 1978 replacement bridge pulling away from one side of the river. A more secure and safer reinforced steel and lumber bridge exists today. (Above, courtesy of Howard County Historical Society; below, courtesy of Ray and Diane Chism.)

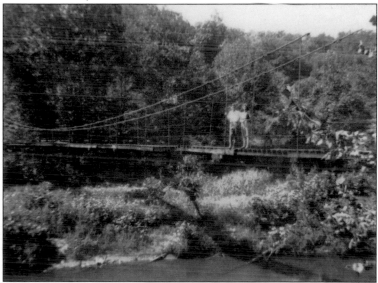

The swinging bridge was a popular stop in the 1960s and up to 1972 for park patrons riding along River Road. The local teens often drove their cars along River Road to meet up with friends, parking alongside the road. Today, the remains of the back stone wall of the Cascade Inn store are visible behind the restroom facility near the swinging bridge. (Both, courtesy of DNR.)

John Bathgate, night engineer for the Patapsco Flour Mill, and his wife, Augusta, were the first occupants of this building, taking in summer boarders and new workers. Later, the building became headquarters for the new Patapsco State Park from the early 1900s until the 1970s. The park shared the building with the Cascade Inn store until it was destroyed by Tropical Storm Agnes in 1972. (Courtesy of DNR.)

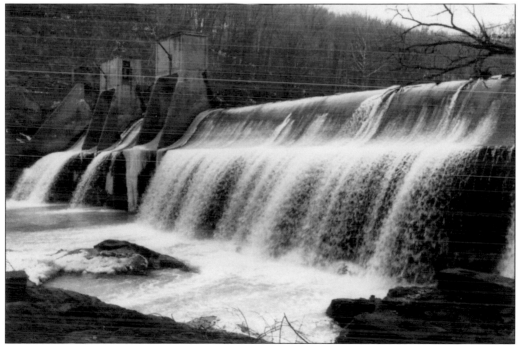

The namesake of this underwater, hydroelectric dam is Victor Bloede. A German immigrant, he is the same chemist and entrepreneur who created the waterworks at Avalon and financed the creation of this unique structure. Built in 1906, it remained in operation until the plant became outdated in 1932. The dam was located in the Orange Grove area of the park until 2018 when it was removed for safety and environmental reasons. (Photograph by Albert Plitt, courtesy of DNR.)

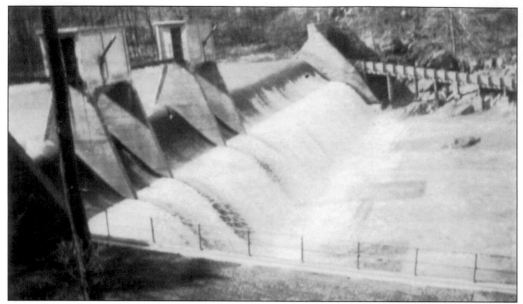

In this 1927 photograph by Mary Prince, there is an especially heavy flow of water over the dam after a recent rainstorm. Even under normal circumstances, the powerful rush of water has proven hazardous, and even deadly, to anyone swimming at the base of the dam. The two towers were removed after damage by Tropical Storm Agnes. (Photograph by Mary Prince, courtesy of DNR.)

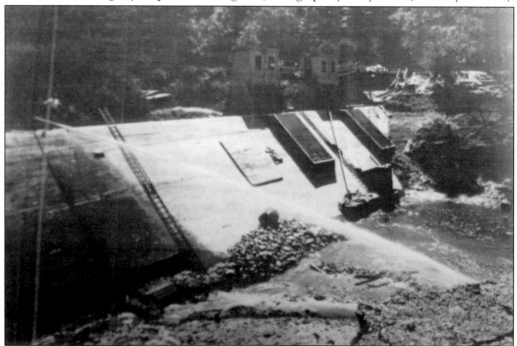

Originally, Bloede Dam was significantly higher than the river bed upstream. This image shows the clearing of sediment around the 1920s. Silt continued to build up behind the dam and for many hundreds of yards upriver over time. In 2017, the riverbed was nearly level with the top of the dam. It was removed in 2018 to address numerous safety and environmental issues. (Courtesy of DNR.)

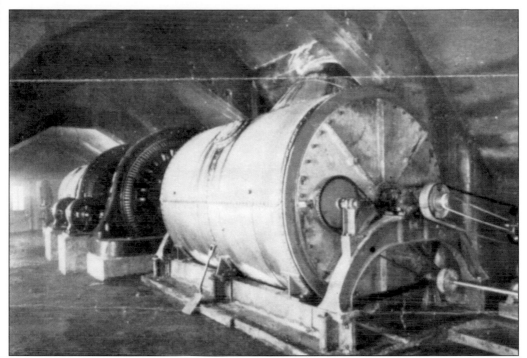

The 220-foot-long, 40-foot-wide hollow interior inside Bloede Dam allowed the generating machinery to be placed directly below the water intake pipes. The river water flowed efficiently through the pipes to turn the water wheels to generate electricity for commercial and residential use. (Courtesy of Baltimore County Public Library and DNR.)

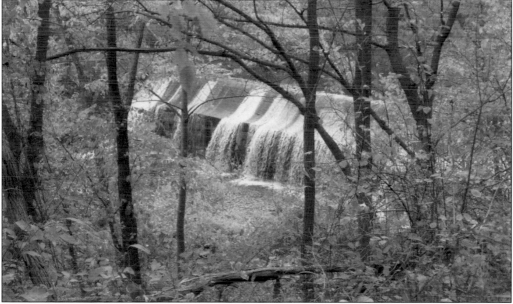

Bloede Dam attracted millions of park visitors to stop along the Grist Mill Trail to view the picturesque scene until 2017. Temporary closure of the popular walking/bike trail was necessary to move the Patapsco interceptor sewer line from the river bank to under the trail before the actual removal of the dam. (Authors' collection.)

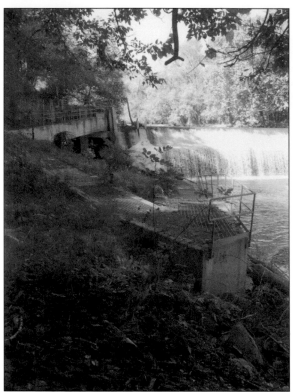

Due to legislation during this period, the first fish ladder was added to the side of Bloede Dam in 1906. After Tropical Storm Agnes, there was discussion on whether the severely damaged dam should be removed. Due to community influence, the dam remained, and a new fish ladder was built. Over time, various kinds of debris clogged the fish ladder, making it less than useful for fish migration over the dam. (Authors' collection.)

In 2018, work began on removing Bloede Dam from the Patapsco River. As part of the project, a section of the Patapsco interceptor sewer line was relocated above the floodplain, under the Grist Mill Trail. An interpretive sign will be installed near the area close to some remnants of this former submerged hydroelectric plant. (Authors' collection.)

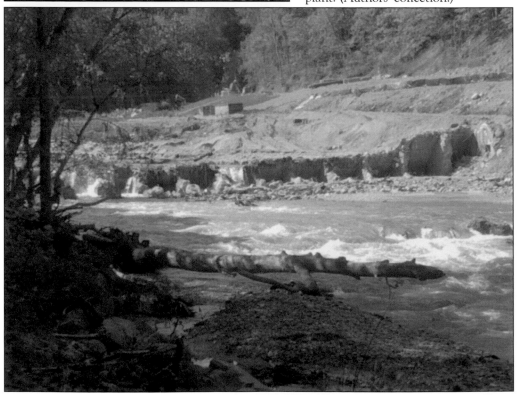

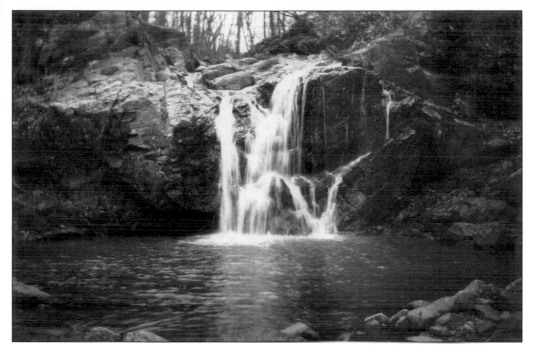

Cascade Falls, formerly known as Marlburg Falls, is one of the most popular and scenic attractions in the Orange Grove area of Patapsco Valley State Park. Located along the Cascade Falls Trail at River Road, this 18-foot-high waterfall is a favorite stop for family photographs and barefoot dips in its cool waters on a hot day. Several smaller picturesque falls are located upstream. (Courtesy of DNR.)

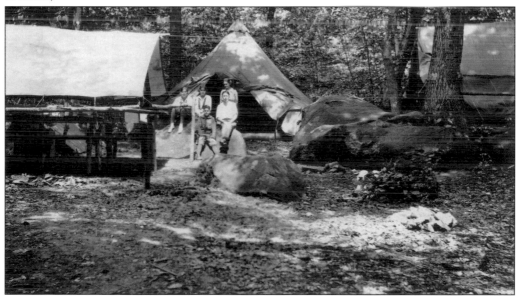

In 1922, Fred Besley and his family pose at their demonstration campsite near Marlburg Falls (known today as Cascade Falls). They encouraged others to enjoy nature and spend time outdoors. As Maryland's first state forester (1906–1942), Besley was instrumental in opening up the Patapsco Forest Reserve for public use and recreation. From left to right are (first row) Kirkland and Fred; (second row) Jean, Helen, and Bertha. (Courtesy of Maryland Conservation Agency Museum.)

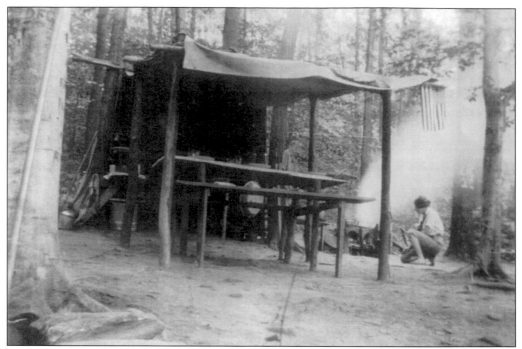

Camp Copperhead was set up by the Hamilton family in a secluded section of Orange Grove during 1923–1927. Park visitors set up elaborate campsites in the same area for the entire summer. This camp was named Camp Copperhead, presumably due to the occasional copperheads observed in the area. Note the loveseat made from twigs and the old-fashioned baby carriage (Both, courtesy of DNR.)

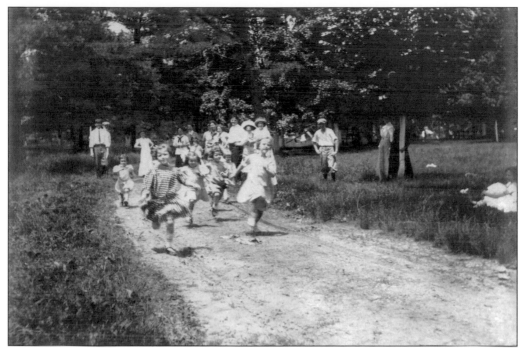

Children at this 1911 picnic enjoyed playing old-fashioned party games in the natural environment. Girls wore dresses, and the rest of their family members would dress up as well—even ties for the fathers. It was quite different from the park apparel of today. (Courtesy of the Catonsville Room, Baltimore County Public Library.)

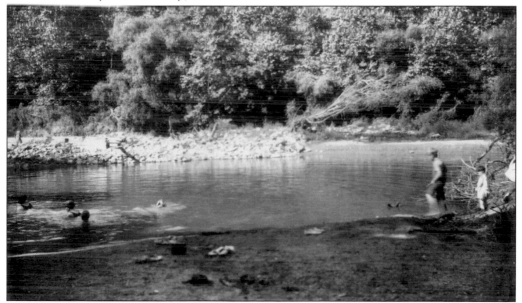

Swimming in the Patapsco River has been a popular activity for over a century. Visitors to the park, especially during warmer weather, continue to enjoy wading in sections where the river is shallow. Although the bathing suits are dramatically different than in the early 1900s, the fun continues for 21st-century swimmers. Orange Grove is one of the favorite areas for swimming and other water activities. (Courtesy of DNR.)

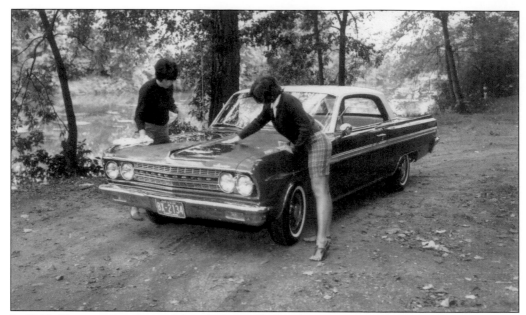

In 1964, Christine Zencker and Angela Connolly found a desirable location to wash and wax this Oldsmobile convertible. Prior to Tropical Storm Agnes in 1972, when the road was washed out, a popular teen activity in the park was waxing cars in the shade along the sides of River Road between Avalon and Orange Grove. Agnes drastically changed the riverbanks and eliminated those parking areas. (Courtesy of DNR.)

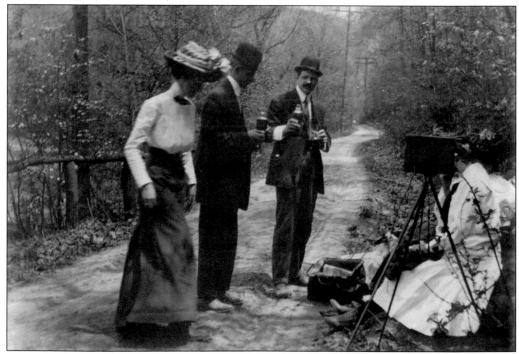

Photography has long been a popular activity for visitors in scenic areas throughout the park. This 1911 image shows the photographer and his subjects taking a break along River Road in the Orange Grove area. (Courtesy of Baltimore County Public Library.)

In 1964, park amenities like picnic tables and grills were located along several sections of the river in the Orange Grove area. Flooding from the devastating Tropical Storm Agnes in 1972 destroyed them. Reconstruction took many years. (Courtesy of Maryland Conservation Agency Museum.)

This 1960 postcard shows Shelter 106 in Orange Grove, which looks pretty much the same today. Family picnicking and shelter use for larger groups continue to be very popular pastimes. Picnickers can hear the gurgling sounds of the nearby Patapsco River from this shelter. (Courtesy of DNR.)

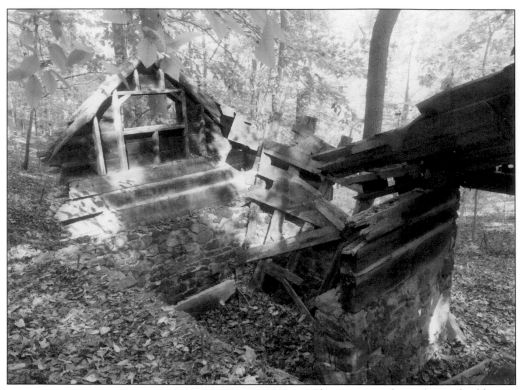

The remains of two shower buildings and other structures formerly used by Civilian Conservation Corps men in the 1930s can still be seen along the Ridge Trail in Orange Grove. (Authors' collection.)

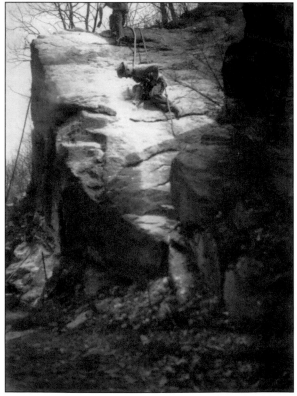

Drilling and dynamiting into rock formations were part of the work of the men from Camp Tydings of the CCC during the 1930s. As a result of this process, the corpsmen widened River Road, which connected Avalon and Orange Grove. This work was overseen by a 16-year-old corpsman in charge of the dynamite crew. (Courtesy of DNR.)

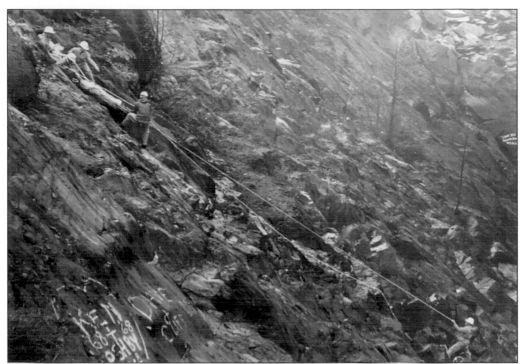

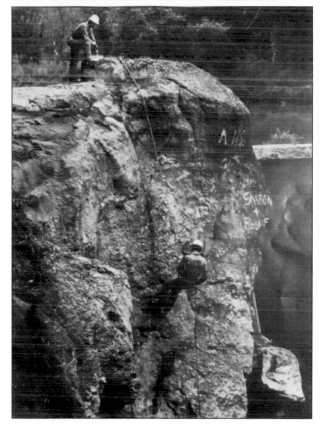

This c. 1970s photograph of Patapsco State Park's search and rescue team shows volunteers who were trained in various kinds of outdoor emergency procedures. They were on call 24 hours a day, seven days a week. Most of the calls were for help and assistance with park visitors attempting to climb the steep rock cliffs in and near the Orange Grove park area. (Courtesy of the Catonsville Room, Baltimore County Public Library.)

Training of the 1970s search and rescue team often involved operating in very rugged terrain. Members were skilled in first-aid and first-aid equipment, types of ropes, safe and unsafe knots, numerous safety devices, handling lost or injured people, ice rescue, and repelling on rocky cliffs. They were trained by the National Guard in orienteering and mobility in unfriendly forest conditions. (Courtesy of the Catonsville Room, Baltimore County Public Library.)

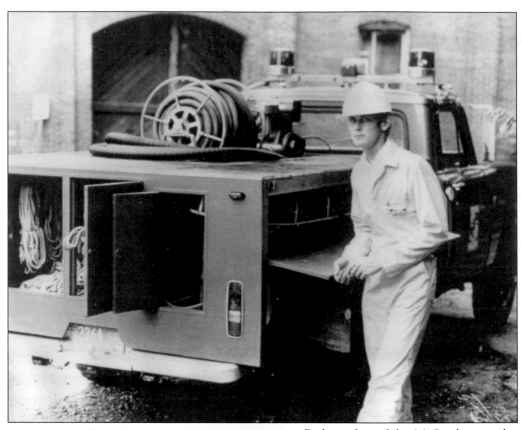

Park employee John McCarthy joined the volunteer rescue team in 1974 and was familiar with rough terrain work. The Department of Natural Resources supplied the truck used by the team. It contained first-aid equipment and supplies, stretchers, ropes, compasses, emergency rations, disposable sleeping bags, and various tools. (Courtesy of John McCarthy.)

This 1939 photograph shows River Road in Orange Grove, which was still unpaved but greatly improved by the use of a stone crusher by the men from the CCC stationed at Camp Tydings in the park. (Courtesy of DNR.)

Four

FLOODS AND STORMS

Severe storms throughout history have played havoc in the Patapsco Valley area, especially the cyclical 100-year floods. Flooding in areas in close proximity to the Patapsco River has been an expected occurrence since the 19th century. The great flood of 1868 caused a significant loss of life and industry destruction along the lower Patapsco River, following on the heels of another damaging flood in 1866. In 1972, Tropical Storm Agnes devastated what had become an active, popular Maryland state park. The winds of Hurricane Agnes had subsided temporarily, only for the rains of Tropical Storm Agnes to bring floodwaters into Patapsco Valley State Park. Within park property, roads, water and electric systems, dams, railroad tracks, buildings, and other property were severely damaged or destroyed. After the flood, park shelters, playgrounds, picnic areas, bridges, dams, restrooms, roads, and historic remains from past flood destruction were damaged or destroyed. Even the park headquarters building on River Road was destroyed. Hundreds of thousands of trees were uprooted, and the sanitary sewer interceptor line running parallel to the river ruptured, spilling countless gallons of raw sewage into the river. It took years of cleanup, repair, and reconstruction before Patapsco State Park could reopen to vehicular traffic and public use. Three years later, there was another damaging storm that furthered the devastation of several park areas and the surrounding communities. Flooding is becoming more common in the 21st century as a result of storm-water runoff from heavy rains and flash floods. As a result of flooding and the damage it causes, now more than ever, community organizations and other volunteers are instrumental in pitching in to help with cleanups and tree plantings to restore the park after devastating storms.

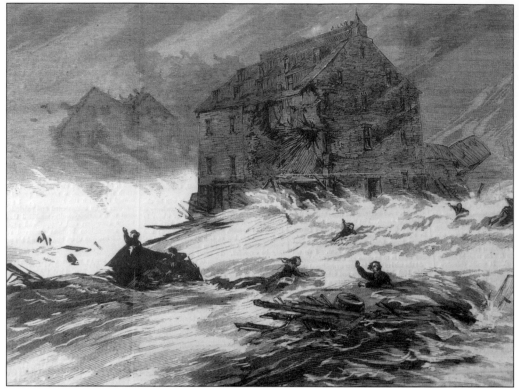

On June 24, 1868, hail, thunder, lightning, and a torrential downpour destroyed homes and businesses close to the Patapsco River. By the close of the storm, the river had claimed 36 victims, carrying some 15 miles downstream. It proved to be the most devastating flood of all time, appropriately named the "great flood" in the Patapsco Valley's history. This sketch appeared in *Harper's Weekly* and was drawn by T.R. Davis. (Courtesy of John McGrain.)

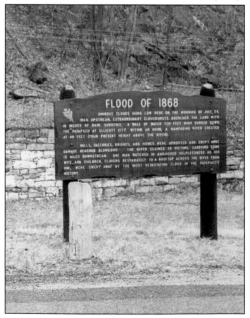

Until it was destroyed by the floodwaters of Tropical Storm Agnes in 1972, this display informed park patrons of the devastation in this area in 1868. Loss of lives, industry, and personal property was tremendous. Other similar historical signs were also washed away in this and other floods close to the river. (Courtesy of Catonsville Room, Baltimore County Public Library)

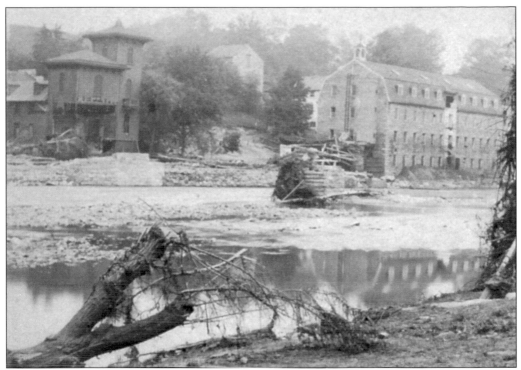

Gray's Mill, the 19th-century cotton factory located off River Road in Catonsville, received substantial damage from the 1868 flood. The remaining section of the mill was further battered by Tropical Storm Agnes in 1972 but was renovated and housed the Catonsville squadron of the Civil Air Patrol. Today, this property is under the curatorship program of the Maryland Department of Natural Resources. (Courtesy of John McGrain.)

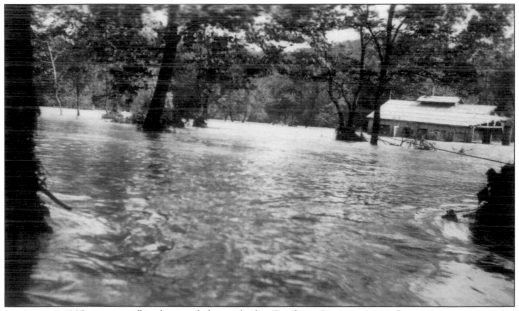

In August 1933, a major flood ripped through the Civilian Conservation Corps tents, surprising corpsmen just a few months after they arrived at the first location of Camp Tydings.

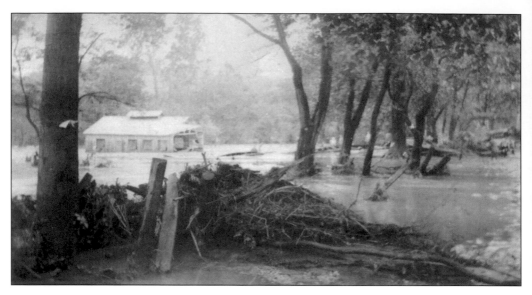

The first camp of the 356th Company of the CCC, located on the Howard County side of the Avalon area, was comprised mainly of tents. In August 1933, heavy rain started to fall upon the tent city for several days with rising water overflowing the riverbanks. The cry "head for the high ground" was heard throughout the camp. The heavy cast-iron stoves from the cooking tents bobbed in the water like floating corks; later, the wooden dining hall was destroyed and washed downriver with smoke coming out the chimney and biscuits still in the oven. The camp was temporarily moved to Fort George G. Meade in Maryland until a more suitable site was ready. The second camp was located in Baltimore County, farther away from the river. (Both, courtesy of Elkridge Heritage Society.)

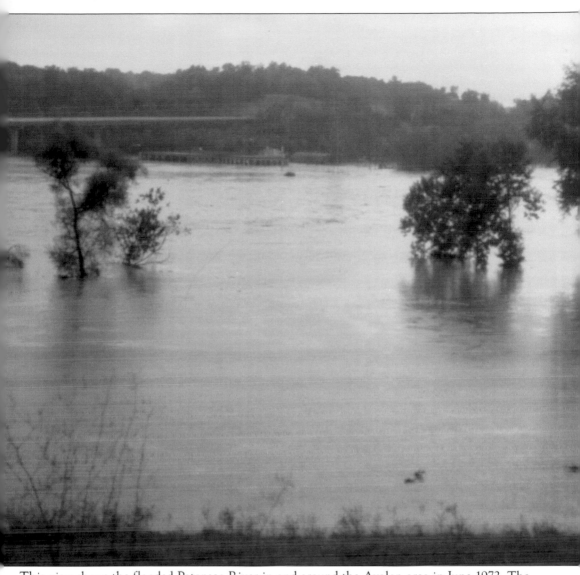

This view shows the flooded Patapsco River in and around the Avalon area in June 1972. The raging floodwaters of Tropical Storm Agnes caused loss of life, personal property, and businesses in the region. In addition to the Avalon, Orange Grove, Hollofield, and Daniels park areas, other Maryland DNR property along the Patapsco River in Baltimore, Howard, and Anne Arundel Counties was also significantly affected. (Courtesy of DNR.)

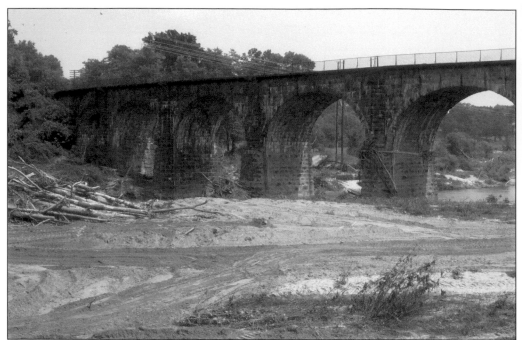

During the 1972 flooding of the Patapsco River from Tropical Storm Agnes, local residents reported seeing the swollen river up almost as high as the tops of the arches of the Thomas Viaduct. Remarkably, this sturdy train bridge has withstood all flooding since its creation in 1833. (Courtesy of DNR.)

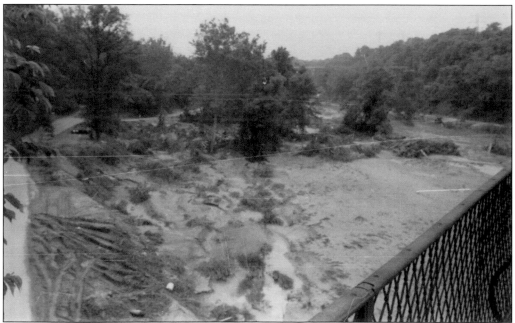

This view from the Thomas Viaduct shows the aftermath of the 1972 flood in the Avalon area. A large amount of sediment washed down the river. Not only was sediment dumped along the riverbanks, the flood also destroyed trees, vegetation, and other structures in its path. (Courtesy of Elkridge Heritage Society.)

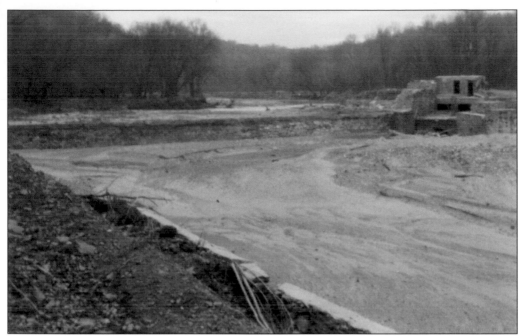

The Avalon Dam channeled river water to the Baltimore County Water and Electric Company's water filtration plant in Avalon. During the 1972 storm, the force of the surging waters destroyed part of the dam and rerouted a section of the Patapsco River. DNR removed parts of the dam structure, although some stone dam wall remnants are visible today just upriver from Shelter 105. Damage to Patapsco State Park was estimated at $2 million. President Nixon declared Maryland a federal disaster area, releasing federal funds for the most severely affected areas. The Army Corps of Engineers was instrumental in helping to clear massive amounts of downed trees, crumbled roadways, debris, and soil left in the wake of Tropical Storm Agnes, which destroyed much of Patapsco State Park. (Both, courtesy of DNR.)

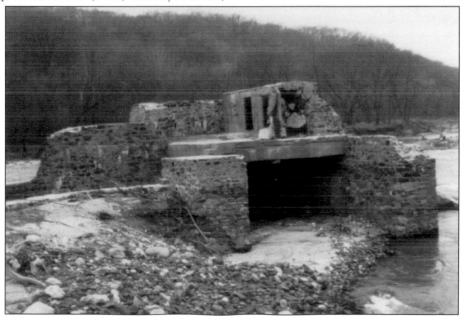

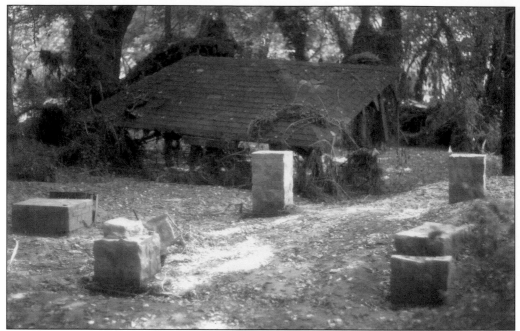

Picnic shelters near the river that were built during the Depression by the young men of the Civilian Conservation Corps were severely damaged by Tropical Storm Agnes. The 1972 floodwaters destroyed many other CCC projects—standing buildings, playgrounds, and other facilities built for public use and enjoyment near the river. (Courtesy of DNR.)

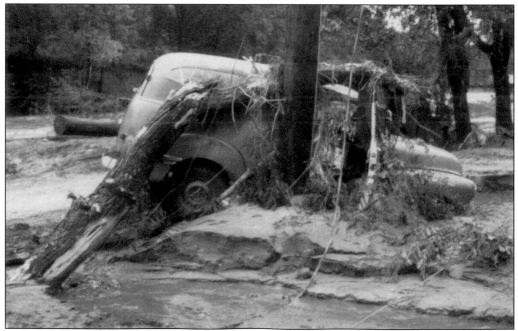

Major floods frequently wash vehicles downriver. In 1972, Tropical Storm Agnes deposited this vehicle along the river's edge in the park along with thousands of trees. Such devastation and debris took years to clean up before Patapsco State Park was reopened to the public. (Courtesy of the Catonsville Room, Baltimore County Public Library.)

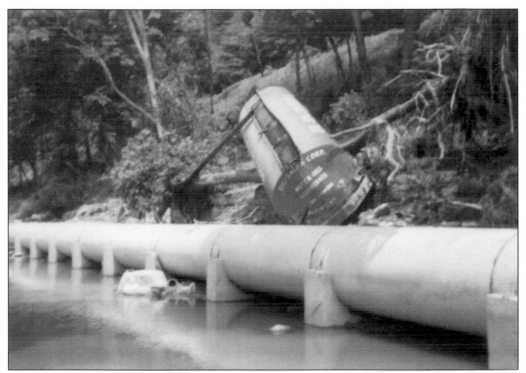

Different types of vehicles frequently wash down the Patapsco River during major storms, including this oil tanker. When waters receded in 1972, the tanker wound up lodged against the Patapsco interceptor sewer line in Baltimore County. Larry Stauffer, along with many other curious hikers and park volunteers, discovered its remains. The tanker was deposited between the river and the Grist Mill Trail, just upriver from Lost Lake. A display panel on the trail identifies the tanker, which was left in place to serve as a reminder of the power of the fast-moving water. (Above, courtesy of John McGrain; below, authors' collection.)

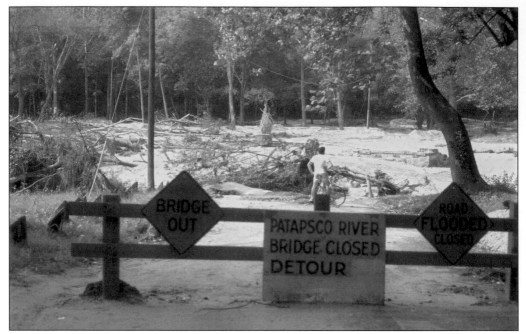

The sole bridge for pedestrian and vehicular traffic in the Avalon area was washed away by Tropical Storm Agnes in 1972. This bridge connected the Patapsco River from Baltimore to Howard County. It was years before debris could be removed. The bridge was replaced, so vehicular traffic could once again return to the Avalon and Orange Grove areas. Stone remnants of the former bridge remain beside the current bridge. (Courtesy of DNR.)

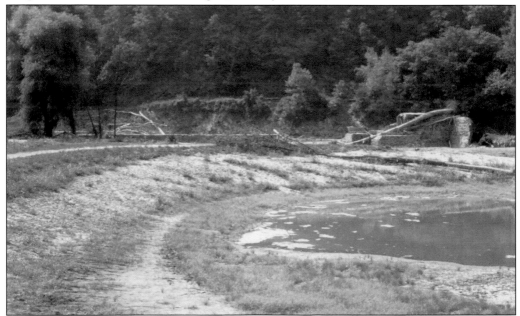

Lost Lake, formerly a millpond for the Avalon Nail and Iron Works in the early 1800s, was virtually eliminated by Tropical Storm Agnes in 1972, but eventually restored. During the 20th century, visitors to the park used to fish, picnic, and ice skate here. Today, it is a popular area to fish and view a diversity of aquatic wildlife and birds in the park. (Courtesy of DNR.)

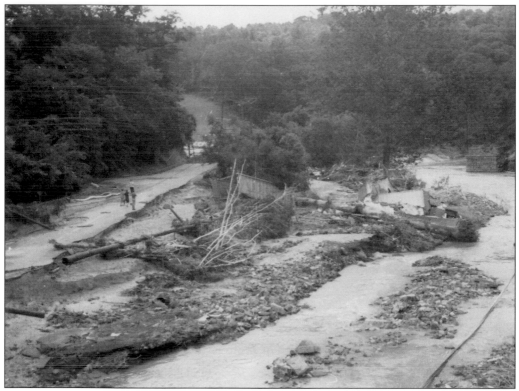

River Road once extended from the Avalon area in Elkridge through the Orange Grove area connecting to Ilchester Road. A section of the road in Orange Grove was partially destroyed by Tropical Storm Agnes in 1972. With so much of the adjoining land washed away, the road was not restored. Today, a portion of the road was transformed into the crushed stone River Road Trail. It extends from Orange Grove to the former Bloede Dam site on the Howard County side of the river. (Both, courtesy of DNR.)

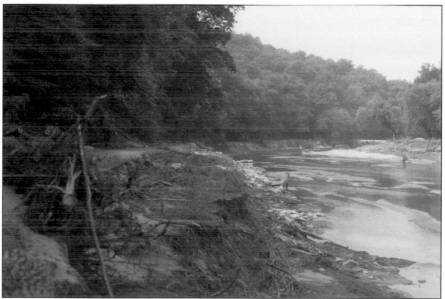

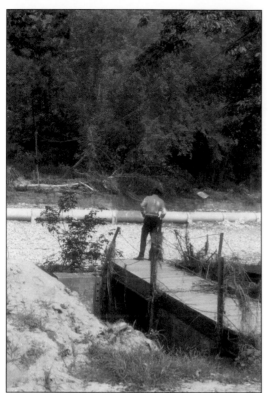

An onlooker examines the remains of the swinging bridge destroyed by Tropical Storm Agnes in 1972. This fifth bridge near the site of the old Orange Grove mill ruins was replaced. A subsequent bridge structure collapsed when the moorings pulled out from one side. No one was injured, and a sturdier bridge exists today. Restoration of the swinging bridge has occurred many times after 20th-century floodwaters damaged or destroyed the bridges. In 1904, a high pile of ice pushed the rather flimsy bridge downriver. A 1925 report indicated 42 boys jumping on the bridge caused it to collapse, resulting in one fatality and two boys with broken legs when they fell 30 feet. (Both, courtesy of DNR.)

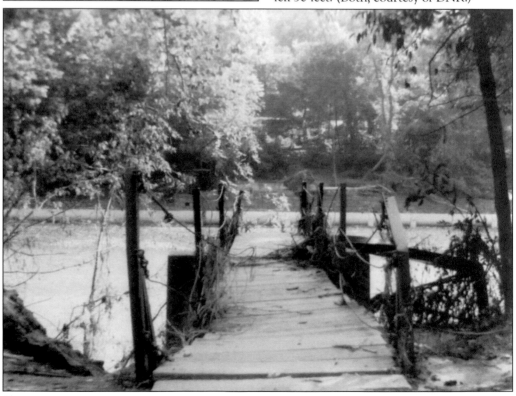

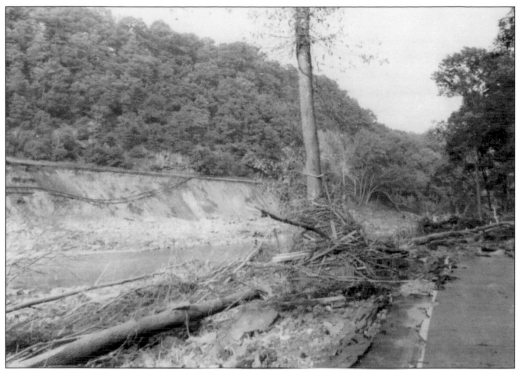

Sections of the Baltimore & Ohio's railroad tracks were left useless as rail beds were destroyed by the floodwaters of Tropical Storm Agnes. Approximately 10 miles of track were washed away near Ellicott City, exposing some of the original stone stringers and stranding a 150-car freight train. (Above, courtesy of Elkridge Heritage Society; below, courtesy of DNR.)

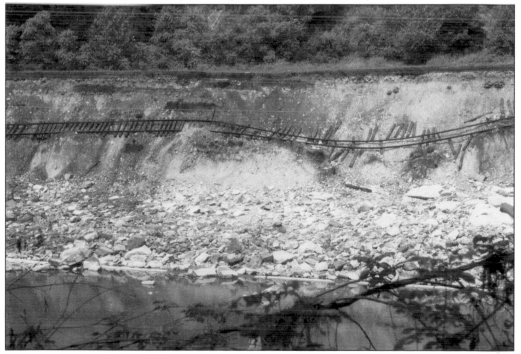

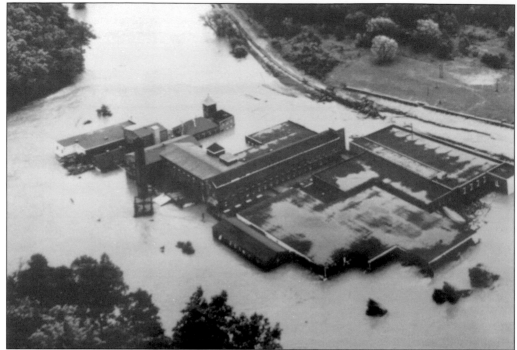

The C.R. Daniels Company owned a thriving textile mill and village flanking the Patapsco River in the mid-20th century. Tropical Storm Agnes's floodwaters rose up as high as the original mill's second-floor desktops. Company plans to restore operations were abandoned when the Maryland DNR purchased a significant portion of the property after the flood, transforming it into the Daniels area of the park. Little is left of the old mill; only one active church still overlooks the remains of the village. The public can see remnants of the mill town from the park's Alberton Road Thru Trail on the Baltimore County side of the river. (Above, courtesy of John McGrain; below, courtesy of DNR.)

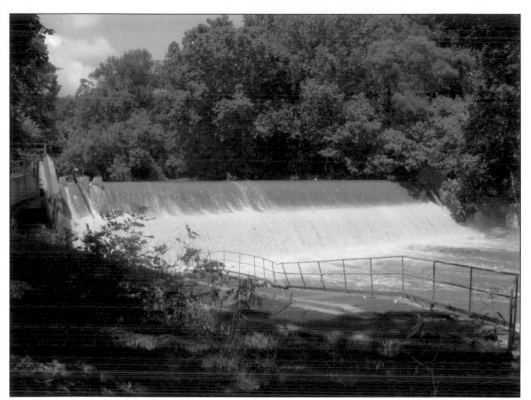

After Bloede Dam stopped producing electricity in the 1930s, there was usually minimal water flowing over the dam during the summer months in the Orange Grove area of the park. The July 31, 2016, flash flood produced approximately six to seven inches of rain in Ellicott City within a few hours. The following day, massive amounts of water still passed over the dam. (Authors' collection.)

Raging waters from overflowing streams and storm water runoff into the Patapsco River produced a devastating flash flood in historic Ellicott City in July 2016. Two lives were lost, and catastrophic damage occurred to properties throughout the historic district. Forty vehicles were washed into the river, and many ended up in parkland, as shown here. (Authors' collection.)

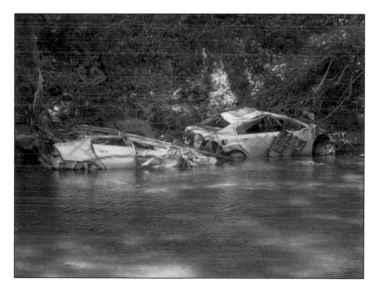

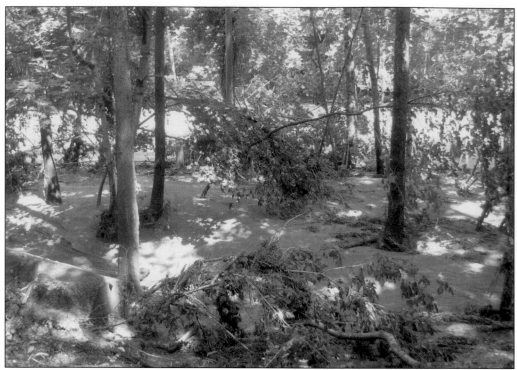

Since the mid-20th century, flash flooding and major storms have occurred more frequently, affecting parkland. Vast amounts of silt, trash, uprooted trees, and other debris are deposited along the river banks by the forceful waters. As shown in this area of Orange Grove, when the water finally subsided, this section along the river received a thick layer of new sediment, and many large trees were uprooted along the river banks. (Both, authors' collection.)

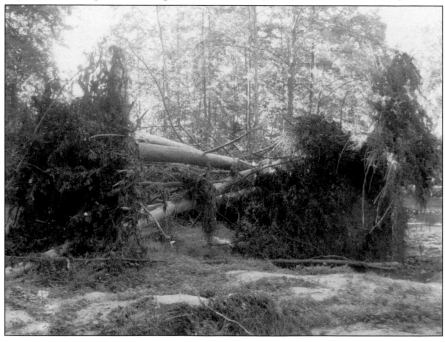

When the 2016 floodwaters receded, the ball field backstop at Shelter 105 in the Avalon area had evidence of mud, leaves and other debris extending up to seven feet high, indicating the high point of the rising waters. Heavy equipment and park workers spent several hours removing the silt to restore the playing field. (Authors' collection.)

Even a footbridge along the Cascade Trail was affected by the torrential downpour from the July 31, 2016, flash flood. Fast-moving water along the stream near Cascade Falls washed away part of the foundation on each side of the footbridge. The bridge and trail were later restored by the maintenance crew of the park. (Authors' collection.)

May 27, 2018, was the second 1,000-year flood to strike the area in two years. The water level from the river rose close to the swinging bridge in Orange Grove, and water flooded the Avalon Ranger Station. Storms can cause significant damage in the park, as shown in these photographs of the Lost Lake area. Park areas with significant damage from flooding are often closed for several days or weeks until repairs are made. (Both, authors' collection.)

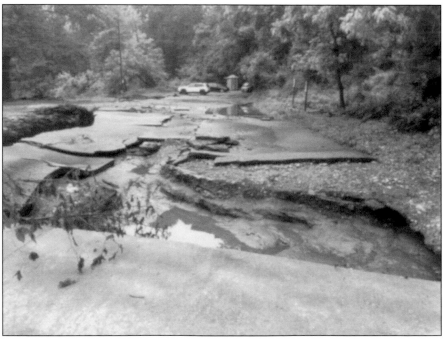

Five

INTO THE 21ST CENTURY

Patapsco Valley State Park encompasses over 16,000 acres of land extending into four counties in Maryland—Anne Arundel, Baltimore, Carroll, and Howard—often adjacent to the Patapsco River. The park boasts 200 miles of nationally recognized trails, 70 of which are maintained trails. In 2018, a marked 33 mile backpack loop trail was created inside parkland, which connects different park areas in Carroll, Howard, and Baltimore Counties; it serves as a great training opportunity for backpackers hoping to hike the Appalachian Trail, or other national scenic trails. Each of its eight developed recreational areas has historical and cultural significance. Over 3,900 acres of environmental areas—Soldiers Delight (Owings Mills), and Morgan Run (Eldersburg)—are managed by park staff but considered separate from the park. The park and environmental areas attract visitors with not only their trails, but their natural and cultural displays, educational programs, historic areas, and unique geography with various endangered plant species. Many of the popular recreational activities of the past, such as swimming, hiking, picnicking, and camping, continue today. Educational and interpretation programs promoting the valley's rich history and natural resources are enjoyed by visitors of all ages. A variety of educational and recreational programs are provided to the public throughout the year. Programs such as the junior ranger and senior ranger programs not only educate children and senior citizens about the park, but also encourage physical activity in the outdoors. With changing environmental concerns and issues, DNR, the park staff, and volunteers work continuously to preserve, protect, and enhance the park's natural resources and wildlife. Dams along the river have been removed to restore its ecosystem. Tree plantings, trash and debris cleanups, invasive plant removal, and water quality testing are just some of the environmental activities sponsored by DNR, the park, and local volunteer groups to help preserve the Patapsco River watershed. With over a million annual visitors, the park relies on dedicated volunteers and other organizations to ensure that its natural, scenic, historic, and recreational qualities remain ready for future generations to enjoy.

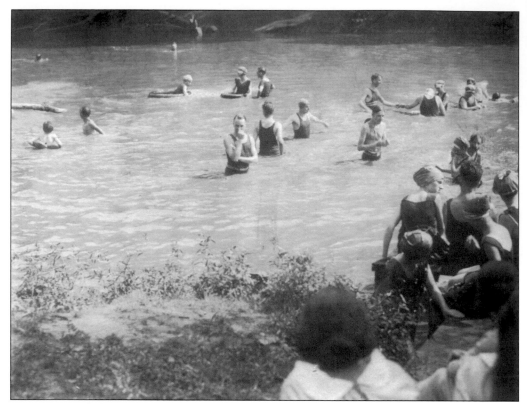

Swimming and playing in the cool Patapsco River on hot summer days has been a major attraction for over a century. In the 1920s, one swimmer commented, "There were about 100 people in the water on the weekends, and the water was crystal clear." Note the tire inner tubes used for wading, and the bathing suits worn in the early 20th century. (Courtesy of William Hollifield.)

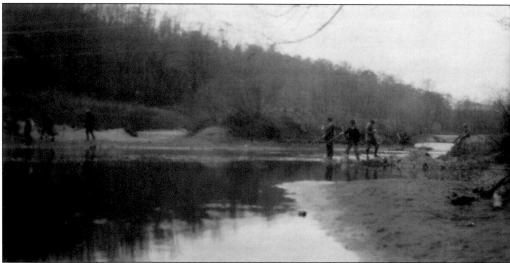

Just above the Thomas Viaduct, this was a popular fishing spot in the 1920s. These early-20th-century fishermen were able to catch fish with only basic equipment. Today's anglers will find a variety of fish species in the Patapsco River, but they will require a fishing license. To fishing enthusiasts' delight, DNR stocks trout each spring. (Courtesy of DNR.)

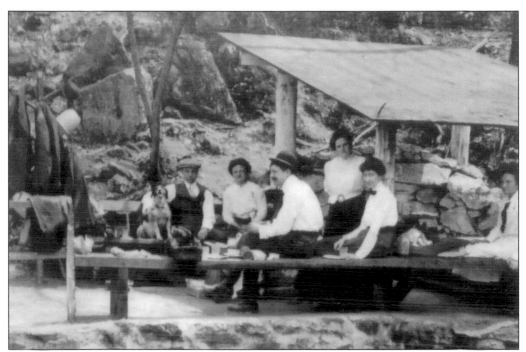

Picnicking was a popular activity for the public in the Patapsco Forest Reserve. In the above 1911 photograph, picnickers in the Orange Grove area wear their Sunday best. Although the park's picnic tables remain basically the same, the shelters have evolved into more permanent structures. Below, this pavilion was built by the Civilian Conservation Corps in the 1930s. Many of these CCC shelters that were built high above the flood zone remain intact today. There are picnic tables in several places in each park area. Rental pavilions of different sizes holding 10 to 200 people are available in various park areas for family reunions, work gatherings, weddings, birthdays, and other special occasions. (Above, courtesy of Catonsville Room, Baltimore County Public Library; below, courtesy of DNR.)

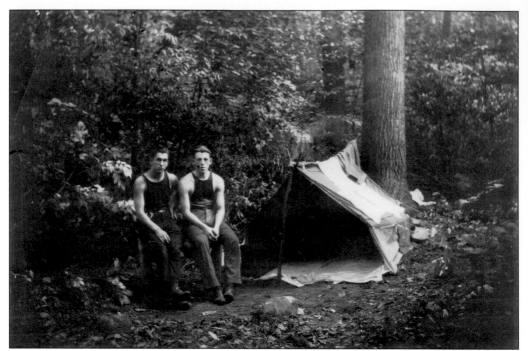

These two young men set up their tent in the Patapsco Forest Reserve for free in 1921. Campers could pick their spot and collect drinking water from nearby springs, but were required to dig their own privy and maintain sanitary conditions. Today's camping areas are in designated park areas complete with picnic tables, fire pits, gravel pads, and nearby flush toilet/shower facilities, encouraging campers to "leave no trace." (Courtesy of DNR.)

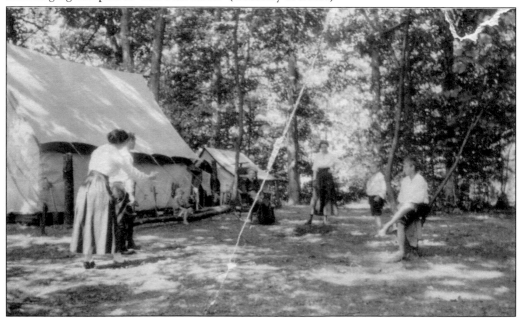

The Andrews family and other campers enjoyed playing quoits. Another popular early-20th-century camping game was croquet. Croquet and horseshoes are still played at picnics today. (Photograph by J. Frank Andrews, courtesy of Ruth Andrew Sherwood.)

This is not your typical rock climbing family; in 1897, these climbers were out for an adventure in the Ilchester woods in their Sunday best. Rock climbing today is a popular activity for many visitors to the park with an assortment of areas where the Patapsco granite hillsides provide challenges to the daring. (Courtesy of William Hollifield.)

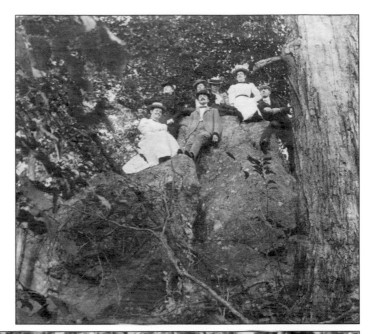

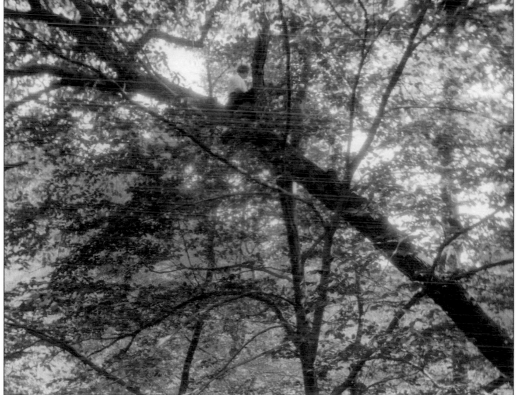

On the back of this 1921 photograph taken by State Forester Fred Besley, he writes, "Some of the campers have gone to the trees." This woman was 40 feet up from the ground. A close look reveals that she was knitting! Tree climbing in the woods is unfortunately no longer a popular activity for children. (Courtesy of DNR.)

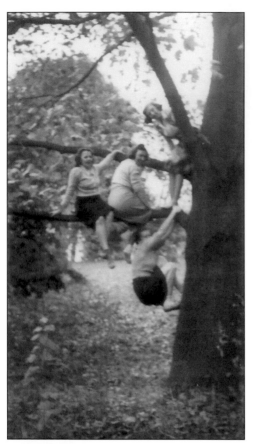

These girls are literally "hanging out" on a tree near the Patapsco River in 1946. Helena Murphy (center) and her sister Edna were born and lived in nearby Oella, opposite Vernon's Roller Rink. They often played with friends along the Patapsco River and River Road in Orange Grove, had picnics there in 1945–1946, and explored the banks of the river down to Bloede Dam. (Courtesy of Richard Gover.)

A common sight in the Patapsco Forest Reserve in the early 20th century was park visitors in their canoes along the Patapsco River. Whether fishing or gently paddling in the river, canoeing and kayaking continue to be popular activities today. (Courtesy of DNR.)

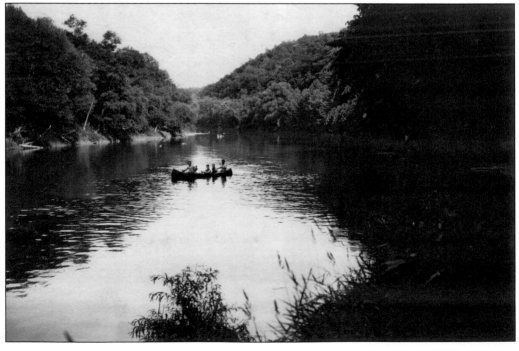

The original Cascade Trail was one of the first rustic trails built in the Patapsco Forest Reserve in 1920. Many of today's trails are monitored and adopted by volunteers through DNR's adopt-a-trail and bike patrol programs. Adopt-a-trail volunteers hike their designated trail at regular intervals, providing general maintenance, clearing debris, picking up trash, and working with staff to maintain optimal trail conditions. The bike patrol volunteers monitor the trails as well. (Courtesy of DNR.)

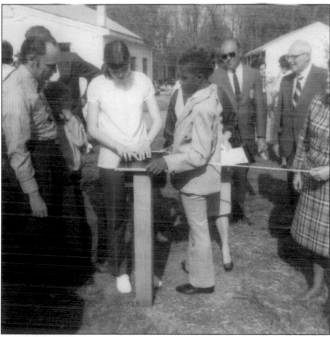

The park's first sensory Braille Trail was dedicated in May 1972, which would begin the momentum to provide accessibility to disabled visitors. Today, there is a more elaborate sensory trail located in the Hilton area of the park. Playgrounds, special paved trails, and fishing aids are just some of the other features being added to different park and environmental areas to enable visitors with disabilities to experience and enjoy the park. (Courtesy of DNR.)

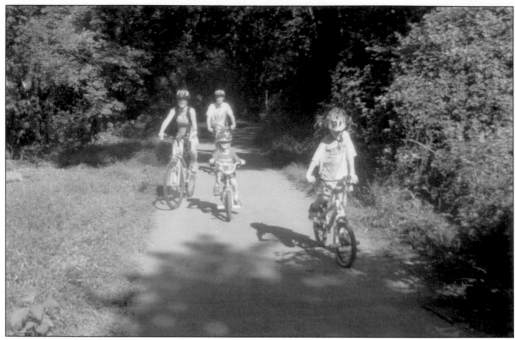

A common site along the popular Grist Mill Trail is biking families. Visitors enjoy this two-and-a-half-mile paved trail through the heavily wooded area between Ilchester Road and Lost Lake, which is gentle and wheelchair accessible. Walkers, joggers, and cyclists share this scenic trail that runs along the river, offering a stroll through history, boasting some of the most beautiful and historic sites in the park. (Authors' collection.)

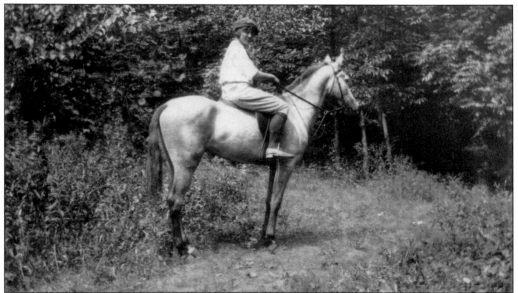

Equestrians, like this YWCA girl, have ridden their horses on trails in the park since the early 1920s. Today, there are numerous designated trails for horseback riding in the park. Visitors may see the volunteer mounted patrols who monitor the trails for the park service. These volunteers provide their own horse, complete extensive in-house training, and serve over 100 volunteer hours a year. (Courtesy of DNR.)

Baby boomers may remember the 1960s playgrounds like this one in the Hollofield area of the park. Most playgrounds were equipped with metal swings, monkey bars, and the exciting—and sometimes risky—merry-go-round. Today's modern park equipment is often made from recycled materials and is accessible for all children and the adults who watch them. (Courtesy of Maryland Conservation Agency Museum.)

This trail marker gives direction along the first overnight backpack loop trail in Maryland built entirely within state-owned park property. Backpackers can choose to start and finish at different locations, making the trail anywhere from 2.5 miles one way to the full 33-mile loop. The trail runs through McKeldin, Woodstock, Daniels, and Hollofield. All hikers are required to register at park headquarters. Overnight camping is located at Hollofield. (Courtesy of DNR.)

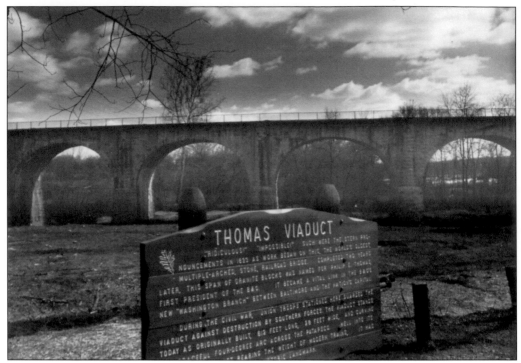

Interpretive signs are an important part of DNR's efforts to educate the public about past history or environmental concerns. This type of wooden sign was displayed in different areas of the park in the mid-20th century. Today's interpretive signs are located near historic remnants, with photographs from the past, many of which can be seen in this publication. (Photograph by Al Plitt, courtesy of DNR.)

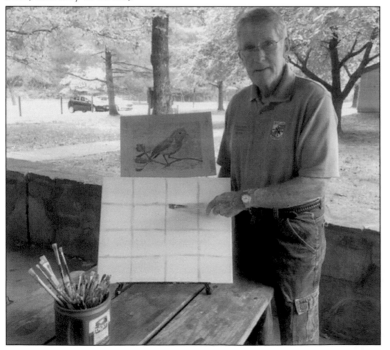

Volunteers are an important component of the park's educational and recreational programs by sharing their expertise with park patrons. Volunteer ranger and artist Ed Johnson shares his talent by providing nature art classes outdoors in the park. Some hikes, recreational classes, or other programs may charge a small fee for supplies. (Authors' collection.)

In 1968, the Maryland Department of Forests and Parks began new interpretive educational programs. In the 1970s–1980s, DNR ranger Jim Roane's reenactments provided information about the history of the valley, as well as the original Maryland rangers. The photograph at right shows ranger Roane in costume educating park visitors, including school groups. Today, the park provides numerous nature and history programs by park staff and volunteers. Below is a picture of ranger Jamie Petrucci with a rescued turkey vulture from the Scales & Tales program. Injured birds, reptiles, and other small animals that are rescued are taken to the Soldier's Delight Nature Center, where they are rehabilitated; those that cannot survive in the wild are used in the Scales & Tales program or are housed for the park's nature educational programs. (Right, courtesy of DNR; below, authors' collection.)

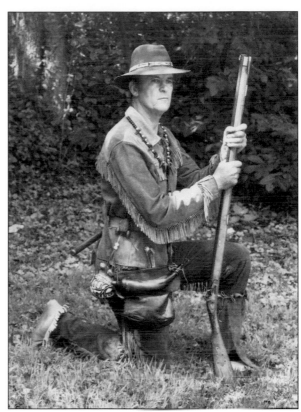

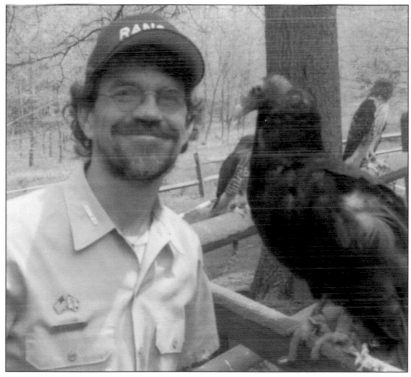

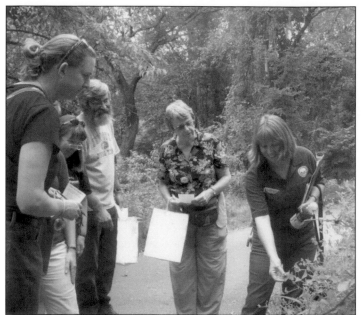

Invasive plant, insect, and animal species have become a challenge for the park. Plant removal events are held throughout the year to remove targeted troublesome invasive plants such as wavyleaf basketgrass and garlic mustard. Unfortunately, new invasive species are being introduced and discovered in the park. Here, volunteer leader Betsy McMillion (far right) educates a group about the troublesome "mile-a-minute" plant, as well as other invasive species. (Authors' collection.)

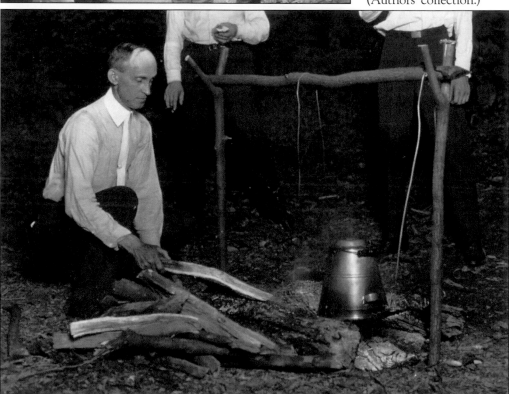

Men dressed more formally in the 1920s for camping in the outdoors. Today, there is no need to wear a tie. Fire rings are provided at campsites and grills at pavilions and other designated picnic areas, and firewood is available to purchase at each campground. Wildfires remain a major concern; rangers are educating the public about the hazards of lit cigarettes and hot coals left on the ground. (Courtesy of DNR.)

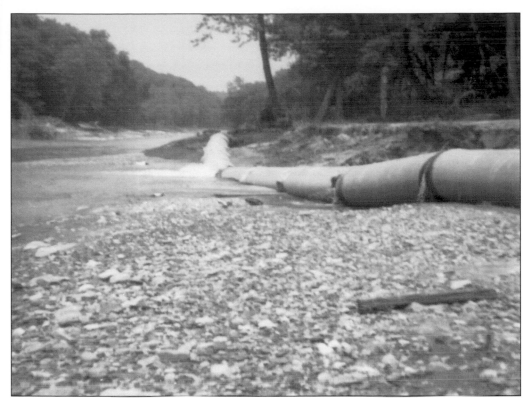

Major storms continue to produce repeated flooding throughout the park. Sewer overflows or breakage from the Patapsco interceptor and piping from other streams flowing into the river present potential health concerns. In addition to downed trees, flooding produces silt in picnic areas, damage to roads and structures. Washed up trash and debris present a challenge to keep the park safe and open to the public. (Courtesy of Joan McGrain.)

"Leave no trace" is an important message for park visitors. Carvings on trees, litter, painting graffiti, and other vandalism destroys the natural and historic beauty of Patapsco Valley State Park. With the help of staff and volunteers, trees are planted annually to expand forestation and replace trees that were lost due to disease, insect infestation, or weather. (Courtesy of DNR.)

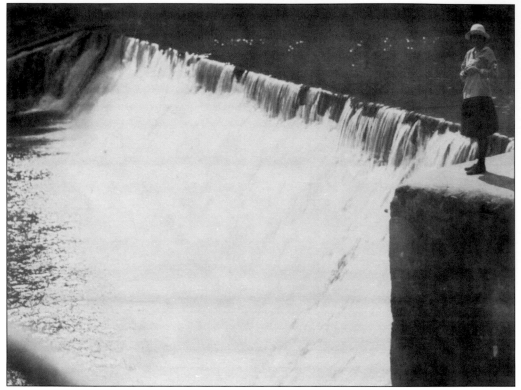

Union, Thistle, and Bloede Dams in the Patapsco River Valley were removed in the 21st century. The dams disrupted aquatic life cycles and prevented native fish and other species from migrating upriver. Even in the early 20th century, this woman did not realize the danger of being on or near the dam, which often ends in injury or death. (Courtesy of William Hollifield.)

Trees and other vegetation that are washed away in heavy rains and flooding cause erosion. Tree plantings, riprap, and other continuous restoration efforts help combat this menace. (Authors' collection.)

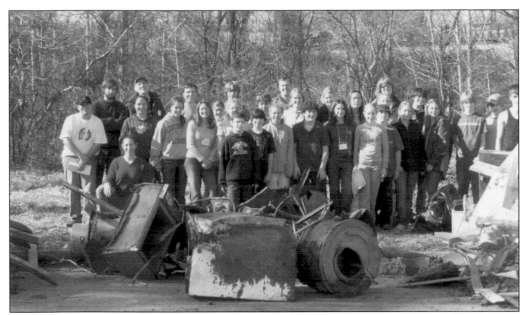

Volunteers of all ages are essential in helping to keep the park clean and assist park staff with many park operations. This group of energetic volunteers helped remove over a ton of trash dumped in a secluded forested area on park property in Halethorpe. (Authors' collection.)

The Elkridge Furnace Inn is a great example of how the Maryland Resident Curatorship Program preserves historic places. The program offers curators the right to lifetime tenancy in a historic property in exchange for restoring it, maintaining it in good condition, and periodically sharing it with the public. Descendants of previous owners and park staff often take advantage of this program for homes on park property. (Courtesy of Howard County Historical Society.)

Trailheads are marked with signs and directional blazes on trees to guide hikers. Kiosks are found throughout the park with trail maps and important information. (Courtesy of DNR.)

Six

OTHER AREAS
OF THE PARK

New Patapsco Valley State Park areas were added or extended over the years to the original 43 acres donated in 1907. Many of these areas witnessed significant historical events that shaped the nearby communities, our state, and even our country. The events in the Avalon and Orange Grove areas have been given the most attention in this book. The areas of Daniels, Glen Artney, Hilton, Hollofield, McKeldin, Pickall, and other former mill communities have historical significance as well. The reader will discover historic dams, former mills and mill towns, stone bridges, tunnels, uncovered remains of original B&O Railroad tracks, a former fire tower, a hidden cave used by early American Indians, the park's first recycled playground, and more. Many of the photographs highlighted in this chapter show scenes that may no longer exist or the remnants of the past that park patrons may see during their visits.

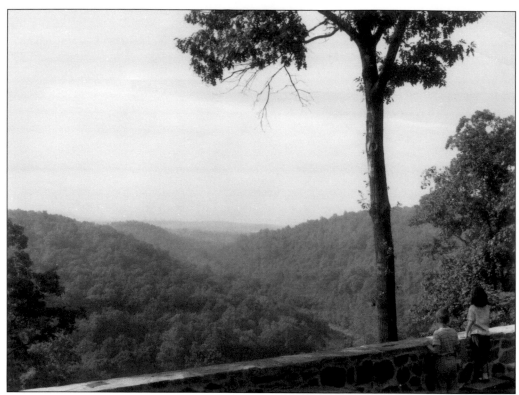

The Hollofield area along Route 40 provides a scenic overlook of the Patapsco River Valley, including a view of the site where Union Dam once provided waterpower to the mill in Oella. The area is named after the Hollifield family, former property owners in the 1800s. The B&O Railroad's misspelling of the family name when a railroad stop was created near the river changed the name to Hollofield. (Authors' collection.)

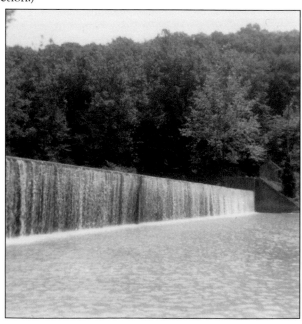

A dam was built in 1810 to supply the Union Manufacturing Company textile mill with water power. It was located below where US Route 40 now crosses the river. At one-and-three-fourth miles long, it is believed to have been the longest millrace to serve a single dam in America. In 1972, Tropical Storm Agnes rerouted the river around the dam. This concrete dam in the Hollofield area was removed in 2010. (Courtesy of DNR.)

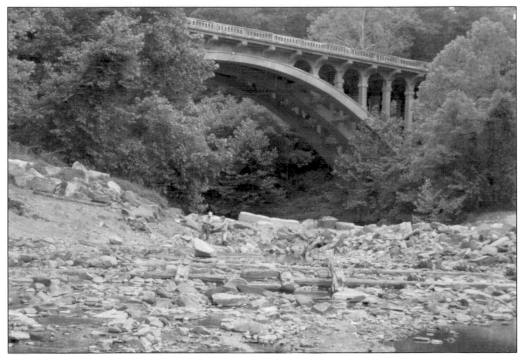

During the demolition of Union Dam in the Hollofield area, workers uncovered an old wooden frame between stone buttresses under the concrete dam. Presumably, they were installed by Union Manufacturing Company to replace the original dam lost in the 1866 flood. The original 1808 stone abutment and the control gates from the 1912 concrete dam may still be seen. A nearby interpretive sign tells the history of Union Manufacturing and the dam. (Authors' collection.)

The 1808 Union Manufacturing Company operated the first textile mill chartered in America. Purchased at auction in 1887 by William Dickey, the Oella mill was America's foremost producer of men's woolens. The Oella mill, rebuilt in brick after a World War I era fire and shown here in 1967, closed in 1972 due to demand for synthetics and double-knits. Today, luxury apartments fill the mill building just downstream from the Hollofield area. (Courtesy of John McGrain.)

In this ad from the 1920s, baseball legend Walter Johnson models a classy woolen suit made of fabric woven in the former W.J. Dickey & Sons Mill. The old mill building remains in Oella and is located on private property just downstream and adjacent to the Hollofield area of Patapsco Valley State Park. (Courtesy of John McGrain.)

Fire towers were built throughout Maryland starting in the early 1900s to quickly detect forest fires. This significant structure was erected in 1940 at the Hollofield area. At an elevation of 550 feet, it could oversee a vast area of the park. The tower now holds modern transmitting equipment within a fenced area near the Old Ranger Trail. (Courtesy of William Hollifield.)

The Hollifield family formerly operated a farm on the property near this historic marker located off of Old Frederick Road in Ellicott City, by the river. The Ellicott brothers' upper mill was approximately two miles upriver from the Ellicott Mills' lower grist mill at historic Ellicott City's bridge. Joseph Ellicott ran the Upper Mill and built his family's home, Fountaindale, nearby in 1775. No remains exist today. (Authors' collection.)

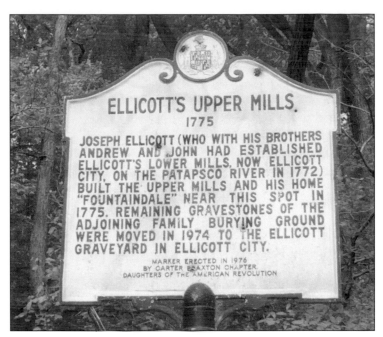

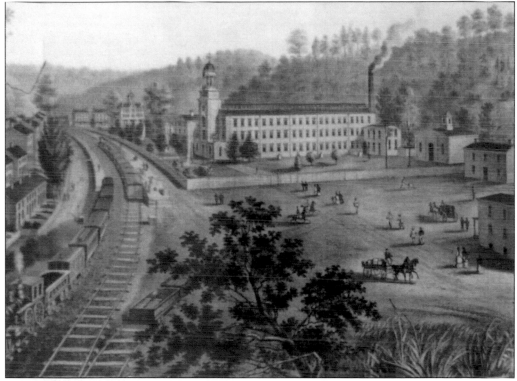

Originally named Elysville in 1840, this drawing depicts Alberton, which was renamed in 1854 and later changed to Daniels in 1940 as subsequent owners purchased the mill. Today, the former Daniels town is located off of Daniels and Alberton Roads. A portion of this former mill town became part of the park in 1976, not long after Tropical Storm Agnes flooded much of the textile mill. (Courtesy of John McGrain.)

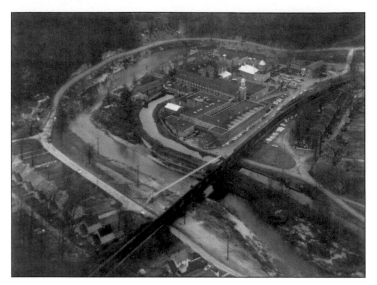

This mid-20th-century aerial view shows the C.R. Daniels Company and textile mill town at its peak occupancy of about 800 people. Canvas and denim products were produced throughout the years, even helping World War I and II efforts. Canvas tents were produced for the Union army in the 1860s by the former Alberton Cotton Factory owner James S. Gary. (Courtesy of John McGrain.)

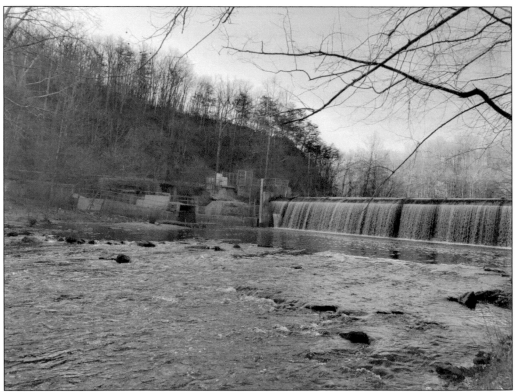

The Daniels dam provided 400 horsepower to the former textile mills making cotton duck products. The dam later provided surplus electricity for the Baltimore Gas & Electric Company. A fish ladder was installed to help wildlife swim upstream. Today, the Daniels Dam is still intact for swimmers, fishers, and paddlers to enjoy the calm waters above the dam. This is the last remaining dam along the lower Patapsco River. (Authors' collection.)

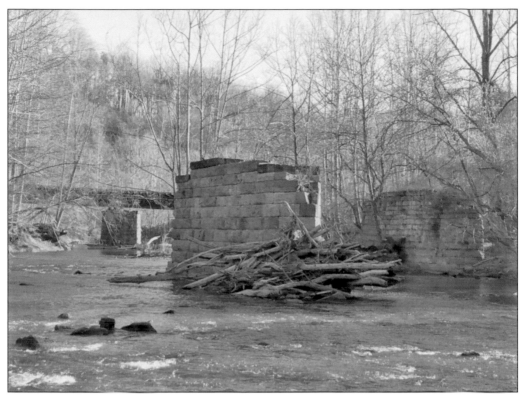

Pictured are the remains of the pier and abutments of the former Elysville lower railroad bridge. This bridge, and the remains of the upper bridge farther upstream, were part of an 1838 realignment of the B&O Railroad to reduce a sharp 18-degree curve. Both bridges were originally wood-covered. They were upgraded with Bollman trusses in the 1850s and later bypassed by another realignment in 1906. (Authors' collection.)

Mill owners provided affordable housing for their workers and families. However, bringing the homes into compliance with the county's plumbing and sanitation codes was not affordable. As a result, C.R. Daniels Company removed the last of the mill worker houses in 1968. After Tropical Storm Agnes in 1972, the company moved its textile operation into Ellicott City. The Maryland DNR later purchased a portion of the property for a new park area. (Courtesy of DNR.)

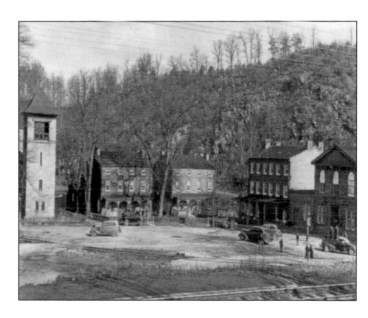

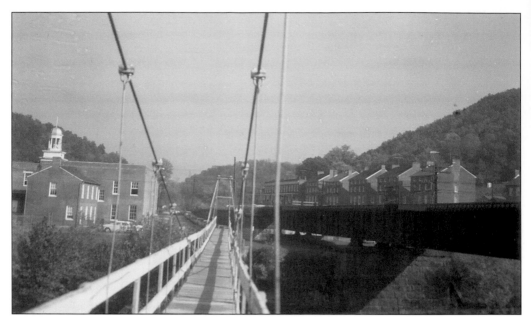

A suspension bridge erected over the Patapsco River enabled Daniels residents to cross between Baltimore and Howard Counties over the flowing Patapsco River. The Daniels Mill bridge connected village residents on both sides of the river to the restaurant, store, churches, the mill, and the railroad. (Courtesy of John McGrain.)

Walking along the Patapsco Thru Trail in Alberton, hikers will discover the ruins from this former Pentecostal church built around 1940 and located across the Patapsco River from the Daniels area in Baltimore County. Visitors can access this trail off Alberton Road in Windsor Mill. (Authors' collection.)

Camel's Den in the Daniels area is the only natural underground cave in Howard County, made out of Cockeysville marble (about six by fifteen feet and six feet high). Artifacts in this area reveal its early use by American Indians, most likely as a temporary shelter where campfire smoke could escape through a ceiling crack. Cross the stream near the boat launch off Daniels Road and follow the unmarked trail to the cave. (Authors' collection.)

The B&O Railroad built this 19th-century granite and brick culvert with a stone arch lining over a stream in the Daniels area. The culvert channeled tributary water into the Patapsco River under where the railroad tracks formerly ran. Made entirely without any mortar, the stone section of the culvert exists today in the Daniels area in excellent condition and appears to be the smallest arch along the line. (Authors' collection.)

In the 1830s, sledgehammers and muscle were used to drive hand-held drills into rock by Baltimore & Ohio Railroad workers. This work was preparation for the blasting of rock to widen the path of the train tracks along the side of the Patapsco River. Evidence of such work can still be seen in the Daniels area on the Howard County side, along the trail that parallels the river. (Authors' collection.)

Remains of the original track from the 1830s can be seen along the unnamed trail on the Howard County side of the Patapsco River in the Daniels area. These granite stringers ran parallel to the track and were used for supporting the metal strap rails. Over the years, stringers in the area have worked their way to the surface. (Authors' collection.)

This early stone culvert allowed water to drain under the tracks of a section of the Old Main Line of the Baltimore & Ohio Railroad in the 1800s. Park patrons today can still see it as they travel along the Grist Mill Trail in the Hilton area on the Baltimore County side of the Patapsco River, just downriver from the swinging bridge. (Authors' collection.)

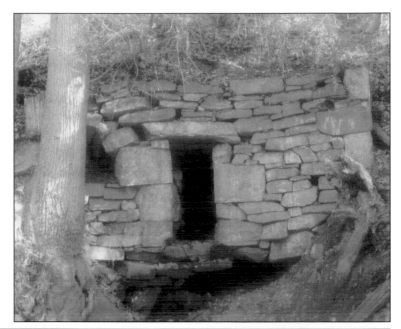

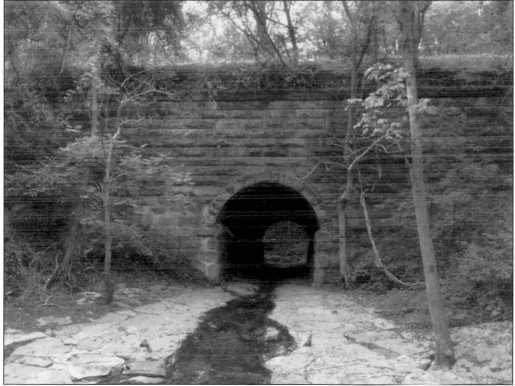

This stone bridge and tunnel was built in 1869 to replace the original structure damaged by the 1868 flood. It is part of the Old Main Line, which supports the railroad that runs across the top of it. Hilton area travelers along the Grist Mill Trail can walk through the short tunnel to access the Forest Glen, Sawmill Branch, or Buzzard's Rock Trails. The stream flowing under it is the Sawmill Branch. (Authors' collection.)

This building was used for various purposes over the years, including a camp store. It was officially dedicated as a nature center in May 2009 and provides a vast array of nature programs, displays, and activities for people of all ages. It is located across from the Hilton area's recycled tire playground, with several renovations. (Courtesy of the Catonsville Room, Baltimore County Public Library.)

Parents and their children today find the Hilton Nature Center an inviting place to visit, engage in many kinds of activities, or have lunch in the outdoors near the tire playground, sensory trail, or tot playground. (Authors' collection.)

Former ranger Laurie Witcher and her father, Walt Miller, were part of the group that helped with the construction of the park's first recycled-tire playground in the Hilton area of the park. Upgraded to ADA standards for accessibility in 2016, it continues to be a favorite attraction for active youth. (Courtesy of DNR.)

On Thursday, May 28, 2009, the 25th anniversary of the Maryland Conservation Corps and the dedication of the Hilton Nature Center were celebrated at the Hilton area. Former governor and founder of the Maryland Conservation Corps in 1984, Harry Hughes, was the special guest speaker along with Nita Settina, superintendent of the Maryland Park Service. Several original members of the corps were also in attendance and were recognized for their service. (Authors' collection.)

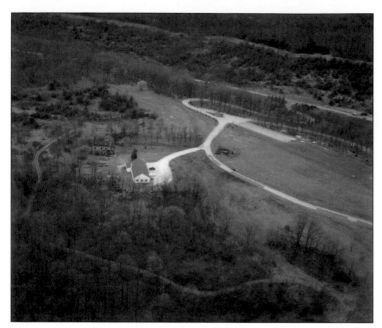

New parkland was acquired by the Maryland Park Service in 1953 and named in honor of Maryland governor Theodore McKeldin. This property was owned by the Flynn family in the 1930s. This 1950 photograph shows the property that was owned by the Markowski family before it became part of Patapsco Valley State Park. The McKeldin area was officially dedicated in 1957. (Courtesy of DNR.)

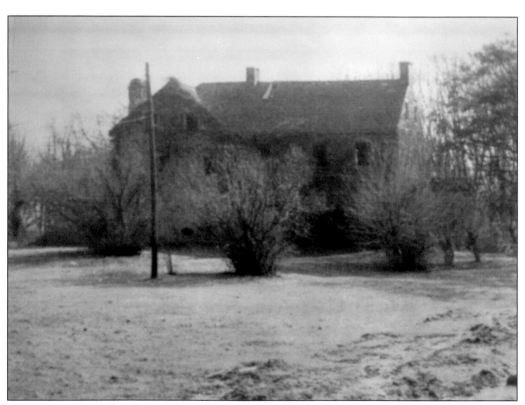

This vacant, rural farmhouse is the Flynn House, a fieldstone structure that was located in the McKeldin area of the park. It was once owned by the prestigious Hammond family. Built in the late 18th century on part of the land that was patented as Tevis Adventure in 1732, it was part of an estate in 1775 that encompassed 875 acres. The house no longer stands. (Courtesy of DNR.)

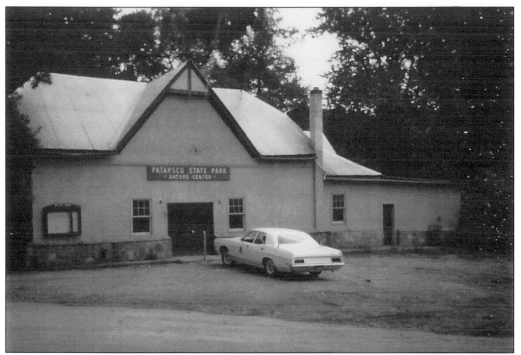

This building was the former Patapsco Valley State Park Nature Center. It was located at the end of Old Court Road by the river, across from the former Jesuit College, near the Woodstock section of the McKeldin area. It was destroyed by fire in June 1979. Arson was suspected. (Courtesy of DNR.)

This 1961 photograph shows a coed ball game in one of the fields in the McKeldin area. Today, the area remains a popular place for different types of sports events, as well as plenty of trails and woodlands to explore. (Courtesy of Maryland Conservation Agency Museum.)

The McKeldin Falls area along the south branch of the Patapsco River was created by the Baltimore & Ohio Railroad in 1831, when the train route was straightened to avoid a dangerous sharp curve. Stone, farm products, and lime were then easily and safely transported to markets in Baltimore by train. (Authors' collection.)

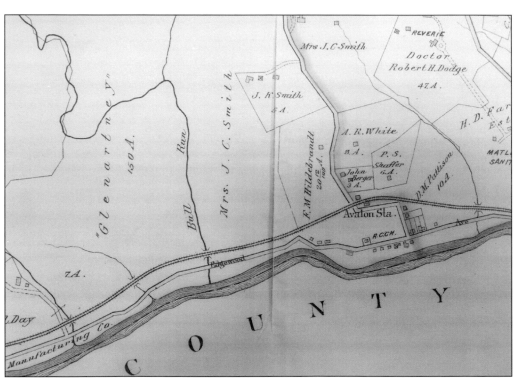

The name of this area came from the original Glenartney estate, which appeared in the 1898 Bromley Atlas, comprising 150 acres owned by J.C. Smith. It encompassed Bull Run (stream) south of Rolling Road, down to Edgewood Road on the Baltimore County side of the river. The Avalon Station of the B&O Railroad can be seen at right. (Courtesy of the Catonsville Room, Baltimore County Public Library.)

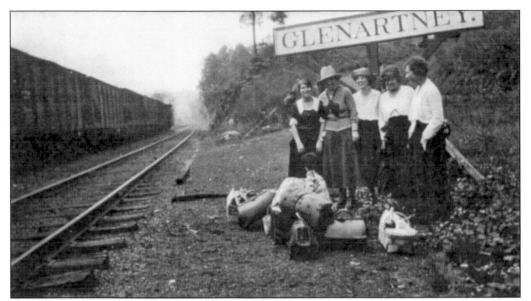

The Glen Artney area became part of the expanding Patapsco Forest Reserve, where train service helped people connect with the outdoors. The Baltimore & Ohio Old Main Line passed near the reserve not only at this stop, but also at Avalon, Vineyard, Orange Grove, and Ilchester. These young campers of the 1920s are waiting at the Glen Artney stop to catch the train home from their camping trip. (Courtesy of DNR.)

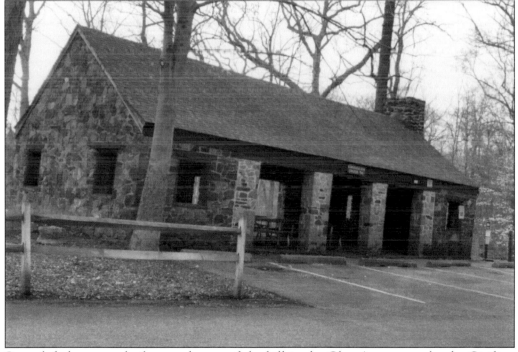

Several shelters were built near the top of the hill in the Glen Artney area by the Civilian Conservation Corps in the 1930s. Away from the floodwaters of the Patapsco River, these shelters were built to be durable and long-lasting. Pavilion 66 and many other structures made from granite remain in use today, offering a glimpse of the past. (Authors' collection.)

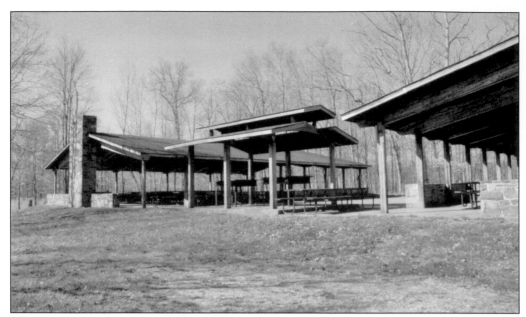

This area is named for A.J. Pickall, who, during his career (1947–1967), was a district forester, chief of park operations, and later superintendent of parks. Large shelters in the area, which require reservations, can accommodate family reunions, large special events, and company picnics, with playgrounds, play fields, and a basketball court. One of the unnamed park trails goes past the area behind the pavilions. (Authors' collection.)

These are the remains in Ilchester of the original Patterson Viaduct, built in 1829 as part of B&O's Old Main Line, washed away in the flood of 1866. A walking bridge built in 2006 sits on its solid footings. It offers park patrons easy access from the west end of the Grist Mill Trail in the Orange Grove/Hilton area across the river to Ellicott City. (Courtesy of John McGrain.)

REDEMPTORIST NOVITIATE, ILCHESTER, HOWARD CO., MARYLAND

The tall building formerly seen in Ilchester above the forest from Patapsco Valley State Park property was St. Mary's College. This was a seminary for young men joining a Roman Catholic order known as the Redemptorists. The postcard above shows the former main building and grounds. The photograph below shows the main building the day after it burned on November 1, 1997. Numerous ghost stories abound about this private property. (Above, courtesy of William Hollifield; below, courtesy of Robert Bailey.)

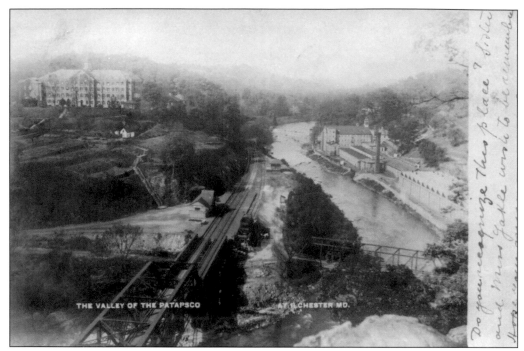

The above postcard shows St. Mary's seminary and terraced gardens on the left hillside, Ilchester train station, and train bridge on the lower left, as well as Thistle Mill on the right by the river. The original 1822 stone textile mill, identified by its cupola, produced cotton. The photograph below was taken after the 1933 flood of the former Thistle Manufacturing Company (1834–1928). The mill was later sold and converted to make paperboard. Simkins Industries was the last operating business on this property, receiving paper recyclables from Howard and Baltimore Counties until it burned down in 2003. (Above, courtesy of William Hollifield; below, photograph by J. Frank Andrews, courtesy of Ruth Andrews Sherwood.)

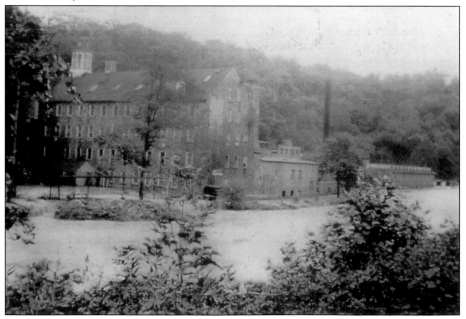

On the hillside above the textile mill and Patapsco River were several stone and frame millworker homes in the village formerly known as Thistle. These modest millworker homes were constructed from local granite. Residents in the 20th century still used outhouses before water and sewer were provided. A few of the existing homes along River Road are now part of the Maryland DNR's resident curatorship program. (Courtesy of John McGrain.)

Edward Gray's Mill (1813–1888) was located just upriver from the old Thistle Mill. It was once one of the largest producers of cotton duck in the country, with 2 slaves, 40 men, and 75 children working the looms. Battered by later floods, the building was later restored and used by the Catonsville Squadron of the Civil Air Patrol. Currently, it is under the state's resident curatorship program. (Courtesy of DNR.)

This 1934 photograph shows Civilian Conservation Corpsmen surveying the land area along Sucker Branch. The Sucker Branch stream is located in Ellicott City. It is a major tributary that flows into the Patapsco River. This is just one of many sections of land along the lower Patapsco River that is protected and monitored by the Maryland Department of Natural Resources. (Courtesy of DNR.)

Seven

IMPORTANT FIRSTS
IN THE VALLEY

It is hard to imagine that any other river valley had such a leading role in the development of Maryland or America. Starting in the early 1600s, numerous firsts occurred in or adjacent to Patapsco Valley Park land. The first European to explore and accurately map the area found evidence of iron ore here, giving rise to the industrial revolution in Maryland. The first iron forge made crowbars for digging up tree stumps, and one of the first nail factories in America was founded. The Union Manufacturing Company was the first manufacturing enterprise incorporated by the State of Maryland, with one of its cotton textile plants in Oella. Numerous other firsts occurred as textile, grain, and paper mills sprang up along the Patapsco River, which provided them waterpower. Transportation and commerce were greatly enhanced when the first commercial railroad in America, the Baltimore & Ohio Railroad, was founded and its first steam locomotive came into use. US presidents made firsts with their travels on the Baltimore & Ohio Railroad. Relay, the first town in America created by a railroad, came to be. After the construction of the Thomas Viaduct, the largest curved, multi-arched, granite railroad bridge in America, communication was further advanced as Samuel F.B. Morse's telegraph line spanned the river at this bridge connecting Washington, DC, with Baltimore. Bloede Dam, the world's first underwater hydroelectric plant, was constructed on the river. Advances in forest management, forest fire control, and public use of the land for recreation were realized through the work of Maryland's first and the longest serving state forester in America, Fred Besley. Patapsco Valley State Park was Maryland's first state park. The first dam and fish ladder along the Patapsco River were located here, as was America's first Civilian Public Service Camp for conscientious objectors during World War II. The Patapsco Valley made valuable contributions as Maryland and America grew.

The first dam on the lower Patapsco River provided waterpower to run the 1760 Hockley Forge and later mills on the property. The forge was founded by the Baltimore Company including Charles Carroll and others. The property later expanded to include a gristmill. (Courtesy of the Catonsville Room, Baltimore County Public Library.)

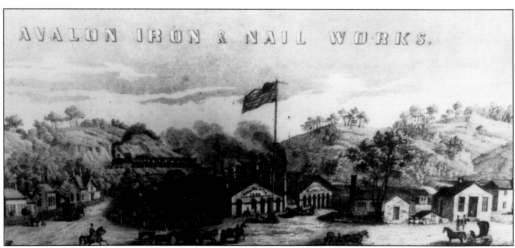

The Avalon Nail and Iron Works produced the first crowbars made in the Colony of Maryland. They were used for prying up tree stumps. An automated nail machine cut out 1,200 nails per minute. Fifty men and thirteen boys were employed, manufacturing a variety of iron products. Dorsey's Forge was formerly part of the complex. (Courtesy of the Catonsville Room, Baltimore County Public Library.)

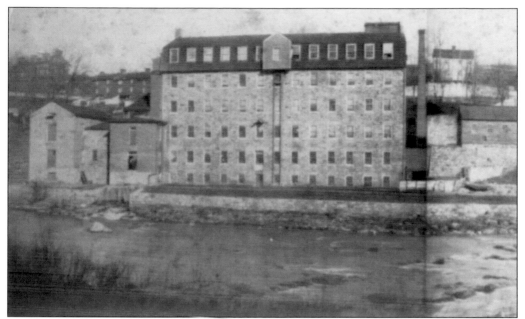

The Union Manufacturing Company was the first manufacturing enterprise incorporated by the State of Maryland. Pictured is one of its cotton textile plants in Oella, which began operations in 1810. The rapid growth of such mills was a direct result of Pres. Thomas Jefferson's embargo on foreign imports. The plant was later sold in 1887 to W.J. Dickey & Sons, which continued operations as a textile plant. (Courtesy of the Catonsville Room, Baltimore County Public Library.)

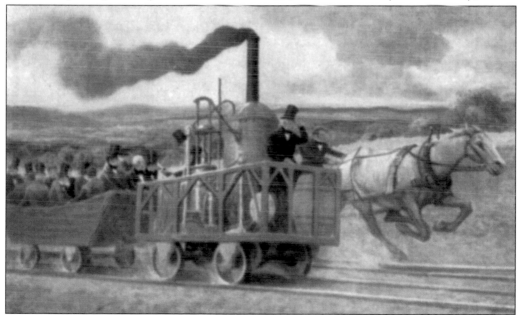

This postcard shows Peter Cooper's experimental locomotive, the *Tom Thumb*. It was the first American-made steam locomotive. According to folklore, the *Tom Thumb* lost this race, but it would soon replace the horse. The Baltimore & Ohio Railroad was the first commercial railroad in America, offering freight and passenger service as early as 1830. For 75¢, one could travel the 13 miles along the Old Main Line from Baltimore to Ellicott Mills. (Courtesy of William Hollifield.)

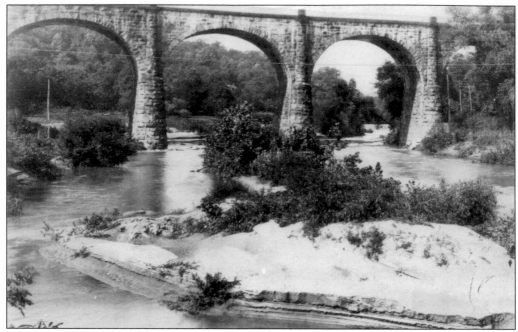

Samuel Morse sent the first telegraph message, "What hath God wrought?" in code using dots and dashes in 1844. Morse's experimental electric telegraph line spanned the Thomas Viaduct in 1843 through Relay, connecting Washington, DC, with Baltimore. The first overhead utility poles in America were used for this transmission when underground proved unsuccessful. Long-distance communication was revolutionized, laying the groundwork for later communication innovations. (Courtesy of William Hollifield.)

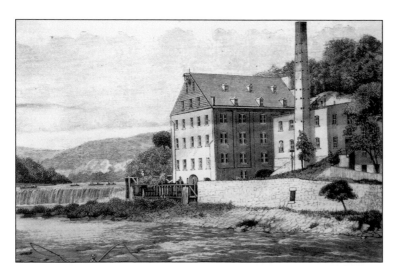

Maryland's first fish ladder was located on the Patapsco River at the Orange Grove Flour Mill. The site had a 10-foot dam where water from the river was harnessed to power the flour mill. The fish ladder was constructed alongside the stone abutment to the dam. (Courtesy of John McGrain.)

The Viaduct Hotel was the first structure built by a railroad in America for exclusive use by its passengers. Located at the "Y" of the railroad tracks close to the Thomas Viaduct, the impressive Gothic-style hotel and station opened in 1873. Constructed of local Patapsco granite with red Seneca stone trim, the hotel was visible on the hill from Avalon. This lost treasure was torn down in 1950. (Courtesy of the Elkridge Heritage Society.)

Fred W. Besley, Maryland's first state forester, served in that capacity continuously from 1906 to 1942. He continues to hold the record for the longest tenure of any state forester in America. Besley was instrumental in opening the Patapsco Reserve to the public. His forest management on public lands emphasized the importance of clean streams and waterways, which continues today under Maryland's Department of Natural Resources. (Courtesy of the Maryland Conservation Agency Museum.)

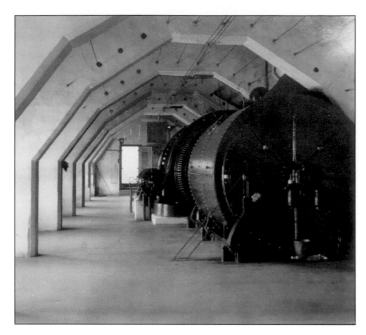

Bloede Dam was the world's first underwater hydroelectric plant. It was also one of the earliest reinforced concrete dams in the United States. Electricity was produced in 1907 for Catonsville and surrounding areas until 1932, including the Eden Terrace community that Bloede built. This photograph shows the inside of the hollow dam that allowed Patapsco River water to turn the turbines. (Courtesy of the Catonsville Room, Baltimore County Public Library.)

In 1907, John Mark Glenn donated 43 acres of his Hilton estate in Catonsville to the Maryland Board of Forestry. This land became the Patapsco Forest Reserve and, ultimately, Maryland's first state park. Today, that original donation is the Hilton area of the park. Another larger portion of the former Hilton estate is part of the Community College of Baltimore County, Catonsville Campus, where the Hilton mansion remains today. (Courtesy of the Catonsville Room, Baltimore County Public Library.)

The first resident forest warden, Edmund G. Prince, served the Patapsco Forest Reserve from 1919 to 1930. His responsibilities included patrolling the park on horseback to put out fires. He often carried fire equipment wherever he went, protecting resources and assisting the public in their enjoyment of the park. (Courtesy of DNR.)

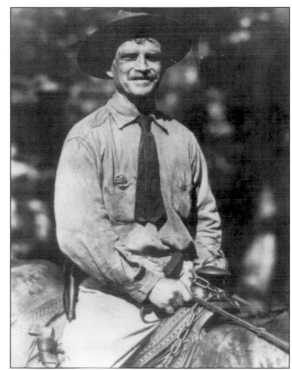

The CCC Camp Tydings in Avalon closed a few years before the onset of World War II. In May 1941, the facilities became the home of a service community of 23 pacifists who continued the conservation projects. This was the first conscientious objector camp in America. The number of camp members grew to 99 by June 1942. Conservation projects were completed, and the camp closed in August 1942. (Courtesy of DNR.)

The first female park ranger in Maryland was Linda Van Wagoner Wilkins. Assigned to Patapsco Valley State Park, she successfully carried out all of the usual duties of a ranger. She utilized her law enforcement training, patrolled the park on foot and on a motorcycle, completed necessary paperwork, and had direct contact with campers. She is pictured in the first row, second from left, in this 1974 Ranger School photograph. (Courtesy of DNR.)

Cindy Hyde was the first female park conservation aide in the Maryland state park system. She was assigned to the Patapsco Valley State Park Hilton complex in the late 1970s after having started her career at Sandy Point State Park. Like the men in her unit, her duties included operating heavy machinery and equipment. Romance often blossoms among park staff, and Hyde later married Rick Holt, a former ranger at Patapsco Valley State Park. The first time they met, she was wearing coveralls and running a chainsaw. (Courtesy of DNR.)

INDEX

Discover Thousands of Local History Books
Featuring Millions of Vintage Images

Arcadia Publishing, the leading local history publisher in the United States, is committed to making history accessible and meaningful through publishing books that celebrate and preserve the heritage of America's people and places.

Find more books like this at
www.arcadiapublishing.com

Search for your hometown history, your old stomping grounds, and even your favorite sports team.

Consistent with our mission to preserve history on a local level, this book was printed in South Carolina on American-made paper and manufactured entirely in the United States. Products carrying the accredited Forest Stewardship Council (FSC) label are printed on 100 percent FSC-certified paper.

MADE IN THE
USA